William T. Cooper

Capturing the Essence

TECHNIQUES FOR BIRD ARTISTS

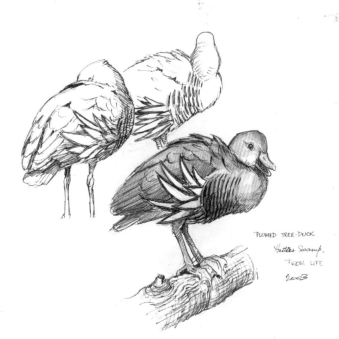

PLUMED TREE-DUCK

Hasties Swamp,
FROM LIFE
2003

DISCARD

CSIRO
PUBLISHING

Yale

UNIVERSITY

PRESS

New Haven and London

Pacific Grove Public Library

7583
COO

© William T. Cooper 2011

All rights reserved. Except under the conditions described in the *Australian Copyright Act 1968* and subsequent amendments, no part of this publication may be reproduced, stored in a retrieval system or transmitted in any form or by any means, electronic, mechanical, photocopying, recording, duplicating or otherwise, without the prior permission of the copyright owner. Contact **CSIRO** PUBLISHING for all permission requests.

National Library of Australia Cataloguing-in-Publication entry

Cooper, William T. (William Thomas), 1934–

Capturing the essence : techniques for bird artists / by William T. Cooper.

9780643101562 (hbk.)
9780643103382 (epdf)
9780643103399 (epub)

Includes bibliographical references.

Birds in art.
Painting – Technique.

743.68

Published exclusively in Australia and New Zealand by
CSIRO PUBLISHING
150 Oxford Street (PO Box 1139)
Collingwood VIC 3066
Australia
Telephone: +61 3 9662 7666
Local call: 1300 788 000 (Australia only)
Fax: +61 3 9662 7555
Email: publishing.sales@csiro.au
Web site: www.publish.csiro.au

Published exclusively in the rest of the world by
Yale University Press, with ISBN 978-0-300-17626-1
Library of Congress Control Number: 2011922767

Front cover: **Australian Shelducks,** *Tadorna tadornoides*
Back cover: **Australian Wood Ducks,** *Chenonetta jubata*
Set in Adobe Arno Pro 11/14 and Bernhard Modern
Edited by Peter Storer Editorial Services
Cover and text design by Andrew Weatherill
Typeset by Andrew Weatherill
Printed in China by 1010 Printing International Limited

CSIRO PUBLISHING publishes and distributes scientific, technical and health science books, magazines and journals from Australia to a worldwide audience and conducts these activities autonomously from the research activities of the Commonwealth Scientific and Industrial Research Organisation (CSIRO).

The views expressed in this publication are those of the author(s) and do not necessarily represent those of, and should not be attributed to, the publisher or CSIRO.

Original print edition:

The paper this book is printed on is in accordance with the rules of the Forest Stewardship Council®. The FSC® promotes environmentally responsible, socially beneficial and economically viable management of the world's forests.

Contents

Acknowledgements

From memory, it was a fellow bird artist Peter Marsack who first suggested and encouraged me to write this book. I am so glad he did, because it was an interesting and enjoyable project. I hope the book lives up to his expectations.

As the manuscript neared completion, the first drafts were sent to friends for criticism and suggestions. All contributed and most, if not all, of their comments were incorporated into the final text. I am greatly appreciative of their ideas and the time they have given to the project. The order of their names is alphabetic and is in no way a reflection of their contribution. They are Ben and Joan Bentrupperbaumer, Marilyn and Peter Chapman, Graham Harrington, Michel Kibby, David Mackay, Peter Marsack, Hugh Nicholson, Nan Nicholson and Penny Olsen.

Greg Scott, the owner of the Raggiana Bird of Paradise painting, kindly agreed for me to use it as the demonstration piece for the 'Painting in oils' chapter.

I am most grateful to my wife Wendy who, apart from many useful suggestions, diligently typed the manuscript and scanned all of the artwork. I thank her for all her help and encouragement through a process that took much longer than was expected.

Thanks to John Manger for considering the work worthy of publication.

Introduction

Drawing and painting birds has taken up a great part of my life and has been most rewarding in many ways. In this book, I hope to be able to help the reader become competent at drawing and painting birds, or at least to enjoy trying. For those who have no desire to draw or paint, but have an interest in the procedure, hopefully these pages will provide an insight into an artist's world. Although this book is biased towards birds of the Australian region, the principles involved remain the same no matter where in the world you are drawing or painting. You may already be a competent artist in another field, in which case you are more than halfway to becoming a bird artist.

Painting or drawing any subject well gives great satisfaction. It is difficult to explain the pleasure derived from finishing a piece that you consider successful, and then walking into the studio a few days later, having not seen it since the last brushstroke, and seeing it anew. On the other hand, sometimes that is when you see for the first time many of the bad points of which you were unaware when you were working on the piece.

By covering a finished work for a few days and then looking at it with a fresh eye, you will know whether it has been a success or not. Painting is full of highs and lows and always reminds me of the title of the film about Michelangelo painting the ceiling of the Sistine Chapel – *The Agony and the Ecstasy.* Talking with other artists, I often find that they similarly experience the highs and lows that come with serious painting, although perhaps not to the extent of agony and ecstasy.

When I was young, even before my teenage years, I would sit for hours enjoying the work of John Gould's artists – particularly Joseph Wolf – as well as the early American bird artist John James Audubon. Looking closely at these pictures gave me a real feeling of being very close to the bird and of seeing all the details that I could not see on birds in the wild. It was like holding the bird in my hand, and thus started my great desire to be able to draw and paint birds.

Apart from the joy of producing a good lifelike painting of a bird, much excitement is to be had in finding, watching and learning about birds in the wild. Seeing wild creatures going about their lives unaware of, or undisturbed by, your presence can be a very enjoyable experience.

There are of course many methods and styles of painting, and I stress here that what I describe is only *my* way of painting birds. There is no single correct way to go about this and hopefully you will develop your own style by adding to whatever you learn from these pages, through lots of practice, and by studying the paintings of other artists. Accomplished bird art can be achieved by using many different approaches. Extreme detail does not necessarily make a good painting. Many people are greatly impressed by fine detail and fail to see bad drawing, composition and structural errors or lack of likeness to the subject. On the other hand, the broad impressionist method can only make a good picture if it has good composition and is true to the bird. The same applies to all styles in between. Be faithful to your subject regardless of whether you are using watercolours with a No. 1 Sable brush or oils with a No. 10 Hog Bristle brush.

Top: Leaden Flycatcher, *Myiagra rubecula*. This is an opportunistic sketch to try to catch the jizz of the bird.

Above: Jungle Babblers, *Turdoides striata*. Another quick drawing to catch the jizz of this species, as they sat fluffed up on a cold morning.

Some artists use birds in decorative designs or stylise them to achieve the result they desire. However, this book is concerned with an artist's ability to produce a painting that gives the viewer a true impression of the bird's appearance. It may be a field guide illustration where the **diagnostic** features of the bird need to be shown clearly for the purpose of identification and where the '**jizz**' of the species needs to be captured. Jizz is the term used to describe the characteristic and often instant impression given by an animal or plant. Even when colour or pattern cannot be distinguished, a bird can sometimes be identified by the way it sits, moves or behaves – its jizz (see below and p. 1). Sometimes it may be the apparent 'facial expression' of the bird, which is created by the angle of the bill or the position of the eye in relation to the bill, and so on. If you can capture the jizz of a bird then your picture will be much more convincing. On the other hand, you may be aiming for a more detailed or more 'finished' painting or a portrait, or even a large picture where the bird or birds are in a landscape depicting the habitat of the particular species.

"Growchilla" – TOPAZ 25th July. 93.

Raised crown

Large head.

WHITE-EARED MONARCH

Quick impression after watching bird
in backyard. – It was giving a plaintive
peep-peep-peep. (not sure how many notes)
in quick succession

Mostly Searching over outer leaves but
then disappeared into the thick
foliage.

Throat white
with band below

white insides of tail conspicuous

Note! Having watched this species again I would say
that the above drawing is a rather good impression of the general appearance.
The head design may not be exactly accurate – see other drawings dated (May 95.)

Left: White-eared Monarch, *Carterornis leucotis*. Birds with complicated patterns usually need to be drawn quite a few times before you can capture their jizz correctly.

Right: Australian Shelducks, *Tadorna tadornoides*, 71 × 56 cm (28 × 22″). Example of a portrait in oils. In this painting all emphasis is on the birds and the light.

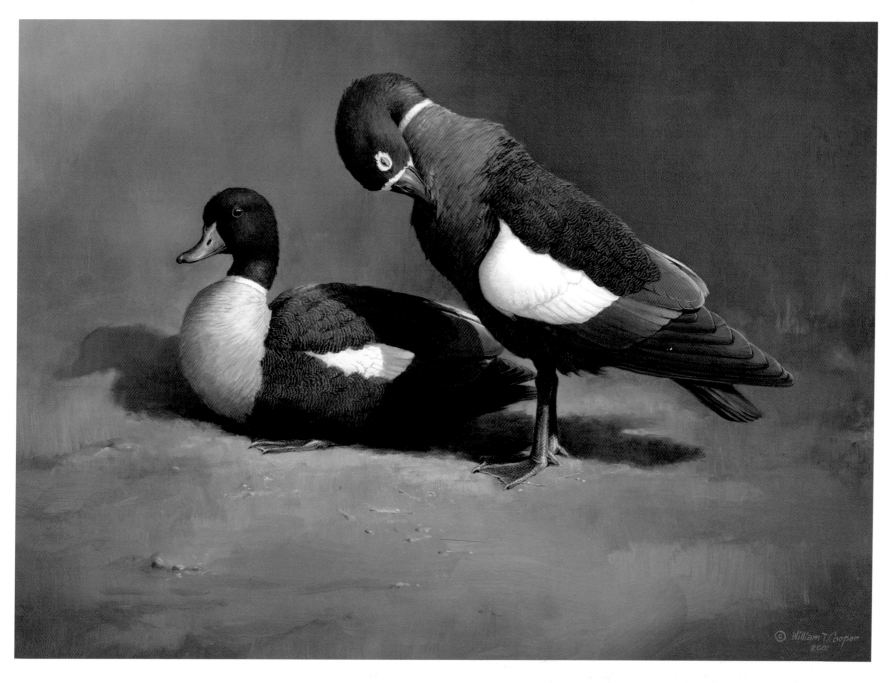

This book is divided into two parts. Part A describes art materials and drawing and painting principles, as well as bird anatomy. Sketching from life is discussed and suggestions made to assist the newcomer to develop the skills needed to draw living moving birds. Part B is made up of painting demonstrations using three different media (watercolours, acrylics and oils). All stages of these paintings are described and illustrated. Some terminology may be new to readers, so a glossary is provided: glossary terms are highlighted in **bold type** in the text.

Painting realistically is the art of creating an illusion by solving a series of problems. It demands good drawing skills and the use of light and shade, tonal values and perspective to make a flat surface appear three-dimensional to the viewer (see opposite and p. 3).

I stress that nothing helps more than really knowing your subject. The more time you spend watching birds, the more familiar you become with their postures and actions. Eventually, you may even be able to do a reasonable drawing of a bird without a model because your mind is able to picture it accurately enough. Drawing from life is very important: it allows much more information to penetrate the mind than when copying from a photograph. This information enters the subconscious and will be drawn upon when required some time in the future. You will also get to know your subject much better. To draw a bird well in many different positions without a model requires a great deal of this accumulated subconscious knowledge, which can be best obtained by drawing from the living creature, or observing it with the intent of drawing it.

To be able to paint birds requires that you are first able to draw birds; in fact, it requires that you are able to draw any subject. I have often heard it said, 'I can draw people but I can't draw horses', or 'I can draw buildings but I can't draw boats'. I believe that if you can draw people or buildings then you can draw horses and boats or anything else. The only thing stopping you is that you have not studied horses and boats as well as you have people and buildings – you have not spent the time to look and see. Looking is one thing, seeing is another. An artist needs to see, and the best way to learn is to draw. Drawing an object forces you to look carefully and study each part before putting your pencil to paper.

John Ruskin, the English author and critic, when explaining to students the importance of drawing, gave the example of a beautiful tree in a park where people walking past stopped to admire it, but after a minute or two they walked off. Then a man came along and sat down to draw the tree. It took him 30 minutes to capture the gnarled and twisted roots, the furrowed bark patterns on the trunk and the branches that were like muscular arms that reached out to hold thousands of leaves to the sun. When the man had completed his drawing, it was clear that he had 'seen' the tree. By drawing it, he came to know his subject.

Right: Wedge-tailed Eagles, *Aquila audax*, 96 × 70 cm (38 × 27½"). Example of birds in landscape in oils.

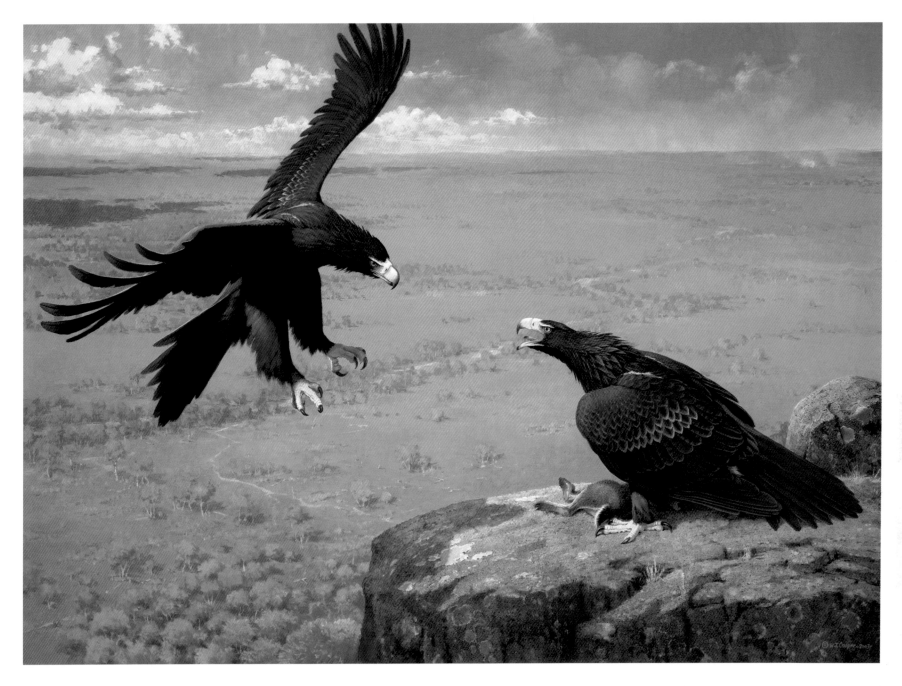

Whether you are a passenger in a car or on a bus or train, there is always enough to look at for you not to be bored. I hear so often, 'Oh what a terrible trip – there was nothing to see'. If you are serious about wanting to draw and paint, then look out the window where there is so much to observe and learn – light and shade on buildings, light on water, trees, cows, and so on. Note how clouds change shape as they get closer to the horizon and change colour as the sun sinks lower. There is always something to study, which, although not a bird, still relates in many ways to painting one.

Learning to draw is learning to see as an artist does. Drawing any subject requires practice, and the more you draw the better you will become. It also requires that you learn to be self critical. Look for what is wrong in your picture and work out how it could be improved. Finally, knowing your subject well allows you to draw it in any position without being reliant on photographs for postures.

ACTUAL SIZE

W.T. Cooper .

FROM FRESH BIRD

Shot by Farmer – Atherton Tableland

Sept. 1997.

Part A – the basics

Fan or Blender

Flat

Rigger (liner or script)

Round

Filbert

Bright

Sable Round

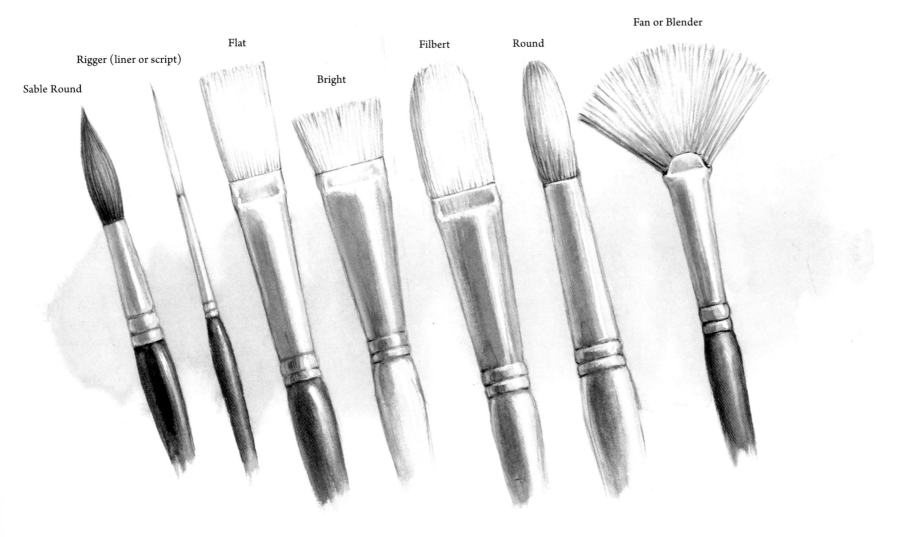

Materials

Birds can be depicted using any one, or all, of the **media** available at good art material suppliers, but in the end it comes down to individual preference. Always use the best materials, or the best that you can afford. Some trial and error will help you find what suits your purpose. There is no reason why you should not use all sorts of media, but, when learning, it is probably better to stick to one for a while. At this point, I would strongly suggest that you try to acquire a copy of a good artist's manual, which will be full of interesting and useful information.

Brushes and knives

Brushes

For painting in oils, Hog bristle brushes are most often used. However, any of the brushes used for watercolours can be used for oils if you are doing very fine detail with thinned paint. Oil paints wear out brushes much more quickly than other media do, and so most artists use Hog bristle or synthetic brushes because they last longer.

Any of the brushes used for oils or watercolours can be used for acrylics. Experiment and find the brush that works best for you and your style.

There are no strict rules about which brushes should be used for which **medium**. However, if you are using watercolours, Kolinsky Sable is probably the best because it will come to a fine point and still carry a fair quantity of paint. Red or pure sable is cheaper and quite good. Squirrel hair is soft and works well in larger wash brushes. Ox hair works well in square brushes but does not point well in round brushes. Goat hair is soft and can be good as a wash brush. Synthetic brushes, such as Taklon, are cheap and can be quite good.

Painting knives

Painting knives can be used for oils or acrylics when doing **impasto** work. They come in different shapes, sizes and flexibility. Painting with knives is more common in landscape work because as a knife lays paint it leaves a visible edge, giving the work a 'painterly' look. However, the great American Wildlife painter Bob Kuhn obtained wonderful effects in his work using a knife or even a piece of card cut to the size and shape required.

Palette knives

These are for mixing paint on a palette.

Left: Some brush shapes.

Media

It is good to have a large range of colours in your studio, but it is not good to use them all in the same painting. Try to use as few colours as necessary. The renowned Canadian wildlife artist Robert Bateman often paints pictures that are almost monochromatic, although if you are about to paint a gaudy parrot in a flowering tree then you are going to have to dip into the colours! Try always to choose the most permanent colours. Paints are rated for colour fastness on colour charts and this is usually indicated on the tube as well.

Acrylics

Acrylics are a very good medium once you have become familiar with their idiosyncrasies and have learned how to deal with them. Like everything else, experimentation and practice is needed (see opposite).

Acrylics have the disadvantage of drying darker than the freshly applied colour. This problem can be overcome to a degree with forward planning and testing, and then mixing a quantity of each colour that you will use. Always mix much more paint than you think you need because quite often you will end up using it. The mixed colours should be sealed in cheap plastic take-away containers and a colour patch painted on the lid. Acrylic paints can be used as watercolours by mixing with a watercolour medium that is made especially for acrylic paint. This has the advantage of allowing many coats without moving, or mixing with, the previous coat. Obtain some books on how to paint with acrylics to learn about different mediums that can be used with acrylic paints.

Black and whites

Black and whites can be created using pencil, charcoal, pen and ink, ink wash, watercolour pencils or scraperboard. Some very effective work can be done using these media. For further details see p. 63.

Coloured pencils

Some beautiful work can be created with coloured pencils, but I have very little experience with them. You may like to experiment for yourself.

Gouache (opaque watercolour)

Gouache is often used on its own or in conjunction with watercolours. Gouache can be applied light over dark and so allows a degree of correction or change, that watercolour does not.

Right: Grey-crowned Babbler, *Pomatostomus temporalis*. This detail – taken from a much larger painting – is an example of acrylics, with fine detail in the bird and freer brushwork in the background.

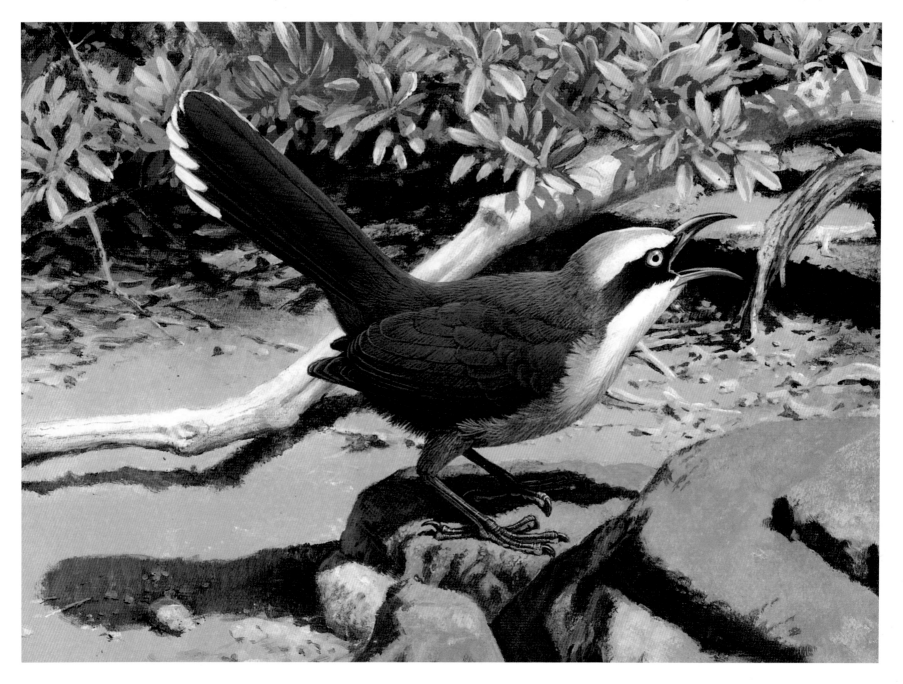

Oils

Oils are a wonderful medium, although some people complain that they are messy and give off objectionable fumes. Messiness can be completely avoided by organising your work area: using white spirit instead of turpentine, and having a lid on your container, and ensuring good ventilation, can help eliminate smells and fumes. Odourless mediums are available if you prefer to avoid fumes.

When using oils, it is very helpful to have a **mahlstick** if you are painting something that requires an amount of detail. This is an armrest commonly used by sign-writers. A mahlstick allows you to work over and around wet areas without your hand touching the wet painting. Good art supply shops keep them or you can easily make your own.

Pastels

Not many bird artists use pastels, although I have seen some extremely good paintings of African mammals done with them.

Watercolours

Watercolours are possibly the most popular medium with bird artists. It is, however, a very unforgiving medium and requires some patience to become familiar with it. When using watercolours, it is difficult to cover a mistake and it needs practice to get the 'feel' of when a first wash is ready to take the next. The more you experiment the better you will become, but there is always an element of chance involved, even for the very experienced artist.

With watercolours, you have a choice of tubes or pans. I much prefer tubes because there is usually less wastage and you don't wear out your good brushes rubbing away at hard paint in a pan.

Supports

Boards for oils and acrylics

Compressed high-density craft 'type' boards should be sanded before primer (**gesso**) is applied. Apply gesso with a brush, working both horizontally and vertically. A house painting brush from the hardware store is suitable for laying gesso. Gesso applied to a board with a fine foam roller gives a lovely 'orange-peel' surface when finished off with a light sanding. Always sand horizontally and vertically with a hand block: do not use a rotary sander. The back and cut edges of the craft board must be sealed with polyurethane, or some other good sealer, to prevent moisture absorption.

Watercolour paints come in four forms and can affect the work greatly so it is important to understand their different qualities.

1. Staining colours are made from finer particles, which penetrate deep into the paper and are difficult or impossible to remove.

2. Granulating colours give visual texture to a painting. The pigment pools and can give a finely mottled effect to washes.

3. Transparent colours can be used in multiple **glazes**; that is, thin washes of colour over another to subtly change, warm or cool it.

4. **Opaque** colours are strongly reflective and cover well. They are neither transparent nor **translucent**.

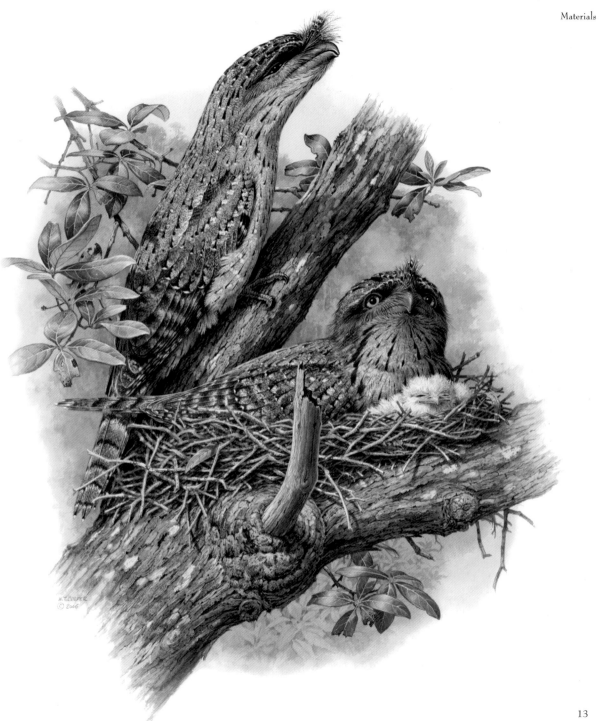

Right: Tawny Frogmouth, *Podargus strigoides*, 51 × 64 cm (20 × 25″). Example of a watercolour vignette. Apart from the green leaves, this is almost a monochromatic painting.

Canvas and canvas boards

Canvas usually comes already primed, but I prefer to apply another coat of gesso and lightly sand it to reduce the **tooth** a little. This depends on the type of painting. If you are painting broadly, then it is probably better to have the tooth. Be sure if you are using acrylics that you use an acrylic gesso (which is also suitable for oils). An oil-based primer, however, is *not* suitable for acrylics. Canvas can be stretched on a frame or glued down to a board. Gluing canvas to a board is best done by a professional framer.

Watercolour paper

It is generally advisable to stretch watercolour paper, unless it is 600 g or greater. Stretching gives a nice 'drum-tight' surface, which does not **cockle**. I am yet to find a satisfactory description of how to stretch watercolour paper. Over the years, by trial and error, I have developed a method that I find works perfectly well for me. Use a piece of plywood 15 mm thick cut to whatever size of paper you wish to work, add 50 mm all around to take 50 mm **gummed tape** (from art supply stores). Paint the board with two coats of polyurethane, sanding between the coats. This seals the board and prevents tannins in the wood from staining your paper. With a broad felt-tipped pen, rule a line 50 mm from the edge on all four sides.

To stretch paper, lay the front side (the side with the readable watermark) down on a clean surface. With a broad **hake** or similar soft brush (or a sponge), coat the back of the paper with water and allow to soak, re-coating occasionally if it appears to be drying too quickly. By wetting the back of the paper the sizing on the front surface is not disturbed. For 300 **gsm** paper, allow about 20 minutes for it to stretch properly; lighter paper will take a shorter time. The paper will be limp when it is ready to turn over. Lay the wetted back on the stretching board. The lines on your board are the guides to get the sheet correctly positioned. Cut four pieces of gummed tape to suit the length and width of the paper. Using a hake brush, wet the backs one at a time and tape the paper edges down with about 10 mm of tape on the paper's edge. A hake brush about the same width as the tape allows application of the water in one long stroke, which then does not remove the glue from the tape. Allow the paper to dry thoroughly (probably overnight) before beginning work on it.

Watercolour boards

Using a board negates the need for stretching paper. Boards are watercolour paper bonded to a backing board. It is important to use the acid-free archival quality boards, which can also be obtained in a range of colours.

Aids

Binoculars

One of the most important tools for the bird artist is a pair of binoculars: choose a pair that allows you to focus on close objects as well as distant ones. If you are sketching in a zoo, binoculars will blur out the wire when you stand close to the cage and will allow you to see your subject clearly. The money you can spend on binoculars ranges from a few hundred to a few thousand dollars. As with most things, you get what you pay for. The expensive Leica Trinovids give crystal clear, undistorted images with true colour rendering. However, some of the cheaper models can also be quite impressive and are generally adequate for use while sketching birds.

The size of binoculars is a very personal thing, but I would suggest that 8×40 is a good all-round size for birdwatching or sketching. Higher magnification binoculars are heavier and harder to hold and exaggerate any hand shake. They also have a smaller field of vision, which means that it is harder to find your bird while looking through them. Good depth of field is a very important capability because it allows you to focus on your subject quickly.

Telescopes

Artists who sketch birds at a long distance, such as in wetlands or on plains, often prefer to use a telescope on a tripod, which, once focused on a stationary bird, allows both hands to be free to draw. However, telescopes are generally more of a hindrance than help when working in forest, but they are excellent for working at nests because the telescope can be left focused on the spot where the bird lands each time it returns to the nest.

Cameras

When working from photographs, you need to be aware that photos do not always produce a good representation of the bird and can lead you into serious errors. A photographer can often take dozens of pictures just to get one or two shots that represent the bird as we might normally see it. Sometimes the posture in the photo can be very awkward and not at all typical of the species. I once saw a painting by an extremely talented and successful wildlife artist that was supposed to be a bird in the wild, but it had obviously been worked from a photograph of a captive bird because it had a clipped wing.

It is not advisable to become reliant on photographs for reference. For example, the colour can be very misleading. The flare of light on a black bill can make it appear pale blue or white. Other colours are often not true to the bird and, in any event, a digital photograph would require the perfect calibration of both computer screen and printer for it to become a reliable guide to the true colour of the bird. Drawing directly from photographs can lead the artist into many traps.

However, if photographic references are used in conjunction with field sketches and a sound knowledge of the structure of the subject, they can be very useful. On the whole, it is much better to get to know the subject, compose your own picture and keep the photos for checking posture and detail.

Please remember that all published photographs are subject to copyright. If you do copy published photos (or paintings), you should not exhibit the result. Also, it is illegal to sell these as your own work without receiving written permission from the photographer, artist or the publisher (whoever owns the copyright).

Hides

A hide – or a 'blind' as it is sometimes called – can be a very effective way of studying birds at close range. Hides are available commercially or can be built with a few aluminium poles and some heavy cloth, or from natural materials such as leafy branches. It is important that the hide is stable and any fabric does not blow in the breeze because any movement is likely to spook the bird. Hides should be erected in stages over some days, allowing the bird to become accustomed to them. Initially they should be placed some distance from a nest, watering hole or favourite perch, then 'walked' in slowly over some days until you are close enough for observation. Keep the hide back from nests: far enough so not to disturb the birds when they are feeding chicks. Some species will desert their nest very easily, so caution needs to be exercised when placing a hide. When using hides, you have a great responsibility not to disturb the bird's behaviour and not to attract predators.

'How-to-paint' books

Books on how to paint in oils, painting **still lifes** or mastering watercolours, and so on, while not especially about bird painting, are full of useful ideas that are applicable to almost any subject matter. Most of the principles you are required to know when painting birds are probably more easily learned from drawing or painting 'still lifes'. I realise that this may sound boring, but much of what you need to learn is often more visible and more obvious in a still life study.

Bird specimens

As much as we all hate finding freshly dead road- and window-killed birds, they are especially valuable for looking closely at any detail. Possessing dead birds without a permit is illegal in Australia, but, before you dispose of these finds, I'm sure you will have time to make the most of the unfortunate death. If you are fortunate enough to have access to museum study specimens, they can also be very useful combined with what knowledge you have of the live bird; note that the feet are invariably shrunken, not in length, but in thickness. Always do detailed drawings of the feet, bill, **gape** and eyes, whenever a dead bird becomes available to you. While drawing, make notes of the toe joints and how there are different numbers of joints on each toe (see p. 39).

Some principles of painting

Tone

Tone is not colour. It is the darkness or lightness of a colour. A black and white photograph is made up of tones of different values. If you were to paint a square half red and half green in colours of equal tonal value, the square would appear as one colour if photographed in black and white.

Good use of tonal values can create effects of perspective within a painting. An important rule to remember is that as the subjects in a picture recede into the distance the tonal values change – *the darks get lighter and the lights get darker!* At a great distance, white is not white and nor is black black. As well as tone, the intensity of colour diminishes with distance.

Getting the correct value of tones relative to each other is one of the most challenging things to achieve in a painting. When you get it right, it greatly enhances the picture. One method of approaching the tone problem is to choose both the lowest tone (the darkest), and the highest (the lightest and brightest), and begin with them. Then work in between those two, looking for the next darkest and the next and so on.

To create three-dimensional effects in a 'bird in habitat' painting, it helps greatly if the background behind the bird is a tonal value of about 4 (see below). This allows you to go darker than value 4 on the shadowed side of your figure and lighter than value 4 on the side that is lit. By working with tone like this, an exceptional three-dimensional effect can be attained. It is as if it makes a space or puts 'air' between the subject and background. This use of dark against light and light against dark is known as 'counterchange'. An example of this is the head and neck of the Cassowary (see p. 18), although in this particular case the background is darker than value 4. Combined with light and shade and lost and found edges (see p. 19), tonal values give a three-dimensional effect to a painting.

Right: It might be useful to make a tone chart starting with black as number one and grading to white in ten equal stages.

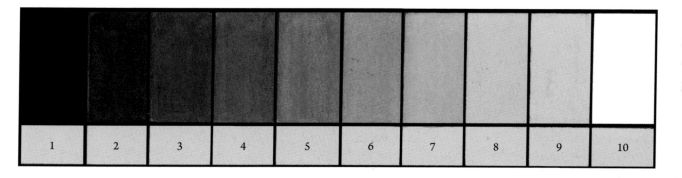

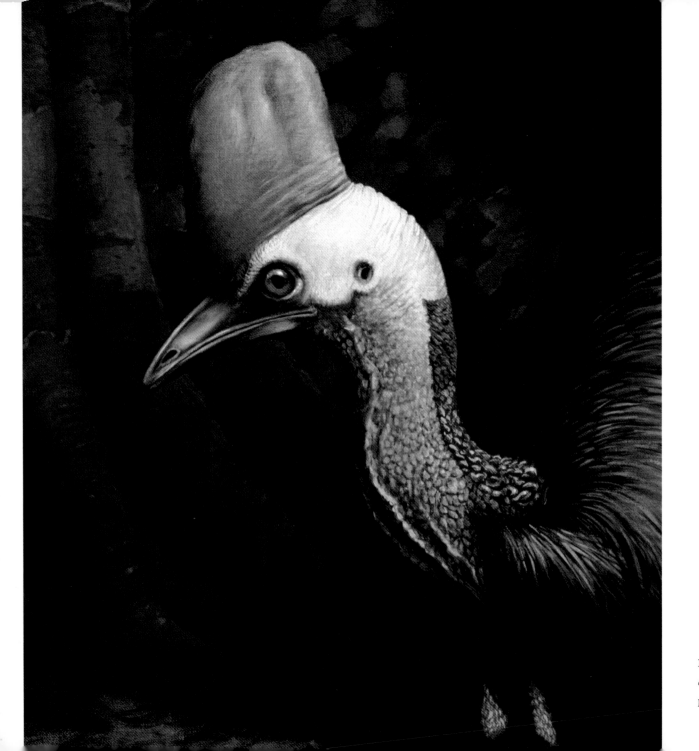

Left: Southern Cassowary, *Casuarius casuarius*. Detail from a large oil painting.

A 'lost and found edge' is when an edge that is lighter than the background behind it, passes from that background into one where it is darker than it, or passes through dark to light and back to dark. There is a small section where the edge is not visible – where it is 'lost' – but it reappears when the tone behind changes, or the subject itself changes tone. The section where the edge is lost is where the tonal values of the subject and background are equal. The eye and imagination of the viewer fill in the piece that is lost.

A good way to understand and learn about tone is to paint a still life using only **sepia** and white. Painting in **monochrome** forces you to concentrate on tone because it is all you have to create the picture. It teaches you to see the darks and lights and all the in-between tones, and to compare one area against the next by tone. I would suggest that anyone learning to draw or paint should try this exercise – you will learn a great deal.

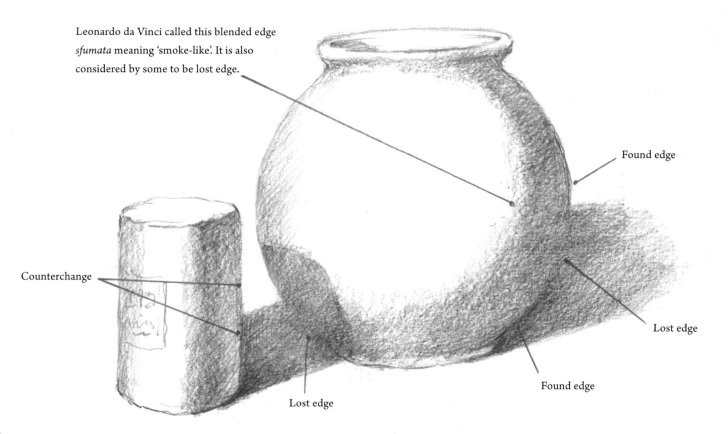

Leonardo da Vinci called this blended edge *sfumata* meaning 'smoke-like'. It is also considered by some to be lost edge.

Found edge

Counterchange

Lost edge

Found edge

Lost edge

Right: Lost and found edges.

Light and shade

The principal personage in a picture is the light. – RENOIR

Light and shade give form to any painting, helping to give it a three-dimensional effect. Light and shade stop things from appearing flat and can be the difference between a good and bad picture. Shadows belonging to the subject will mould its shape and give it form. The shadow of another object (such as branches or leaves) travelling across the surface of the subject will also give form and depth. An example of the latter is demonstrated in the leaf shadows across the tails on the page opposite. Shadows are not necessarily the same tonal value throughout. The tone is deeper where the leaves are closer to the tail (a) and this helps to change the angle of the sprig of leaves in relation to the tail. If the leaves were parallel to the tail, as in (b), then the tone of the shadow would be even throughout. Note also how light is reflected back into a shadow area from other objects. This creates light within shadow: another very useful means of giving form to your subject. Principles of light and shade are well demonstrated below.

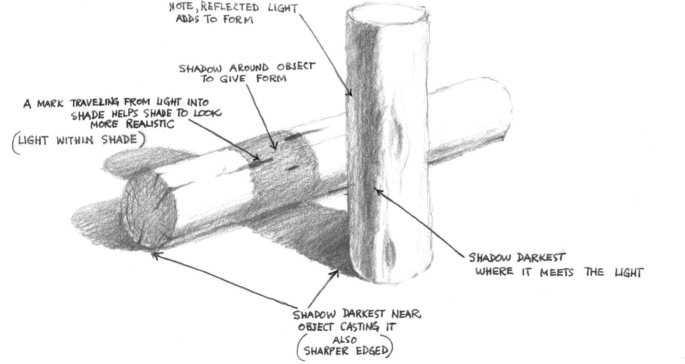

Left: Light and shade demonstrated.

Remember that what you know to be black is not black when in sunlight. It is only black on the shaded side of the subject and in the sun it is a grey of some sort. Depending on surrounding colours, or on the sky, white is not white when in shade. Try to make the 'seeing' of light and shadow your daily routine. Study light and shade as if you are about to paint it and you will learn to see as an artist does.

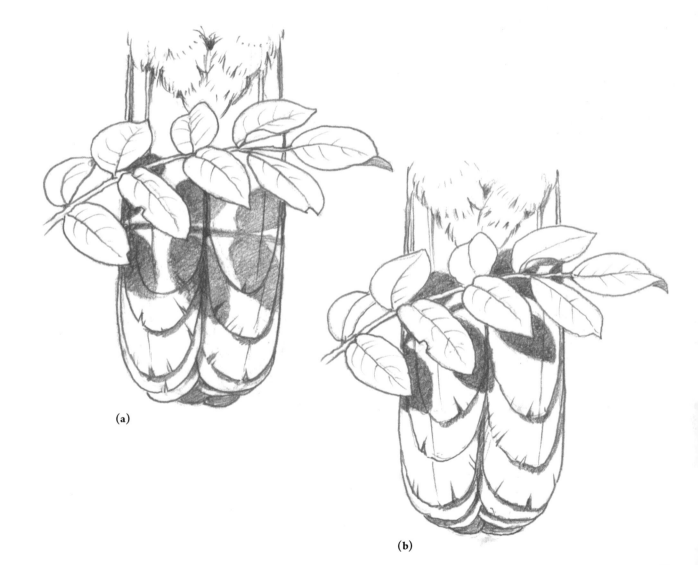

(a)

(b)

Right: Shadows travelling at different angles.

Colour

There is a temptation when painting a bird to get the colour 'correct'. It is desirable that you do, but not to the detriment of the light and shade. If you are illustrating an identification painting for a field guide, then it is important that you get the 'local colour' (the true colour of the bird in good light) correct. However, when painting a portrait or a bird in its environment, often the colour on the sunlit side of your subject will be 'burnt out' to a degree, and the shadowed side will be darker than the local colour. If you achieve this balance correctly, then, without being conscious of it, viewers will adjust their 'reading' of the painting so as to see the correct local colour.

Composition

Composition is the arrangement of figures or objects in a painting to give balance and harmony. A composition may be triangular, square, round or any design that holds a picture together and allows the viewer, without disturbance, to see what the artist intended you to see.

There is much 'composition' theory available and what is stated in one publication may well be contradicted in another. Sometimes good artists break all the so-called rules and still produce wonderful paintings. I believe that common sense will tell you when you have bad composition. If your design pleases you, most probably it is a reasonable, or even a good, composition. Being a little cynical, I suggest that some 'compositions' emerge only after the painting is finished.

Composition is rather flexible and comes naturally to many artists. When composing a picture, artists see what works and what doesn't (see opposite). The success of a painting is whether or not it 'communicates' what you are trying to express, and not whether it fits a particular compositional formula. An obviously bad composition will not help you achieve your goal. If you feel a need to know more about composition, I suggest that you research it further in publications that deal more fully with the subject.

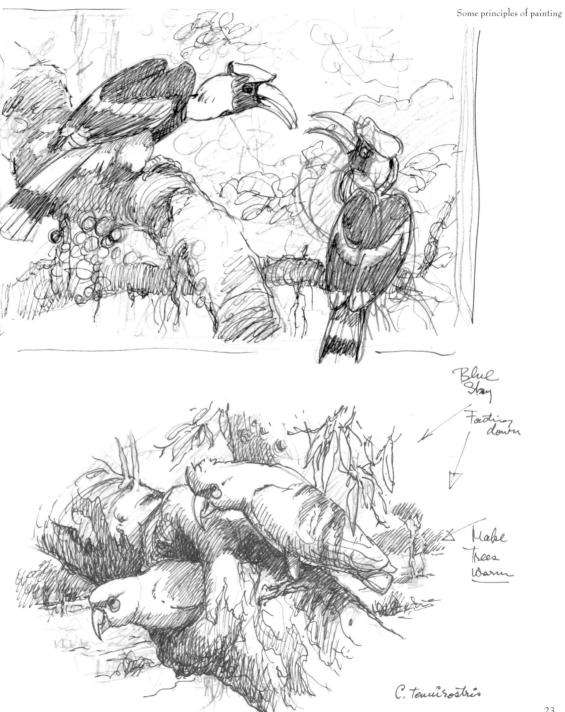

Handwritten annotations on illustration:
Blue Sky
Fading down
Make Trees Warm
C. tenuirostris

Right: (top) Great Indian Hornbill, *Buceros bicornis*, and **(bottom)** Long-billed Corella, *Cacatua tenuirostris*. Small sketches done to work out composition and passage of shadows. Often many layout sketches such as these are done before arriving at a composition, which eventually becomes the plan for a picture.

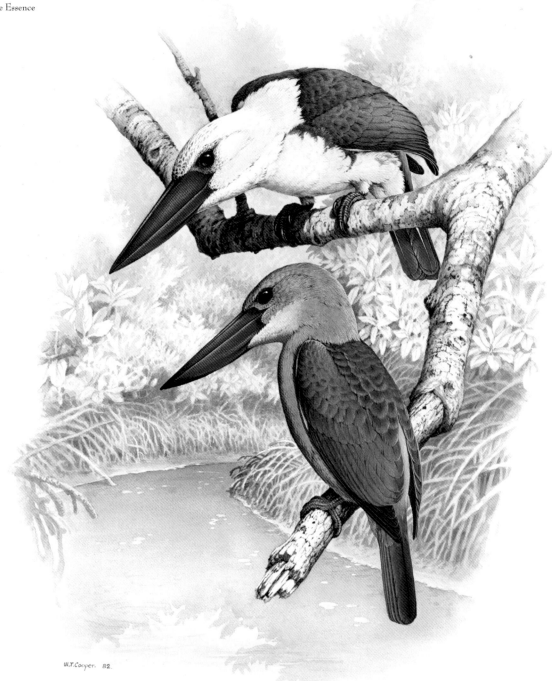

W.T.Cooper. 82

Left: Stork-billed Kingfisher, *Pelargopsis capensis.* The upper bird is an example of foreshortening of the body.

Foreshortening

Foreshortening is making your subject appear shorter by manipulating visual perspective. This can be challenging, but careful observation can usually solve the problem. It is drawing skill that will help you overcome the obstacle.

As portions of your subject become further away from you, they are going to change in tonal value. In reality, this change would not be discernible over the length of the bird's body, so this is where your 'artist's licence' (change to achieve a desired effect) can be used to create the illusion of the end of the tail for instance, being further from you than the base of the tail. By making sure that the end of the tail is ever so slightly paler than the base, the impression of distance is created. Make sure that the change in value is very slight; otherwise the bird will look as though it is coming out of a fog.

The illustration opposite is an example of foreshortening, except for the head which is turned side on to the viewer. To foreshorten the head (see below) the centre ridge of the bill (**culmen**) is at a point that would be the centre line of the head, and the bill becomes shorter than if the bird were seen side on. The eye moves closer to the back of the head as well as becoming more of a vertical ellipse. The whole bird becomes shorter. The wing feathers appear more curved at this angle and the distance between the legs becomes greater. If the bird were to turn even more towards the viewer, then the base of the bill would move even further into the head, the eye shape would appear more vertically elongated and seem even closer to the back of the head.

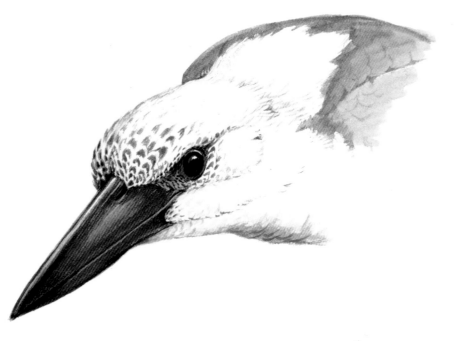

Right: Stork-billed Kingfisher, *Pelargopsis capensis*. Example of a foreshortened head.

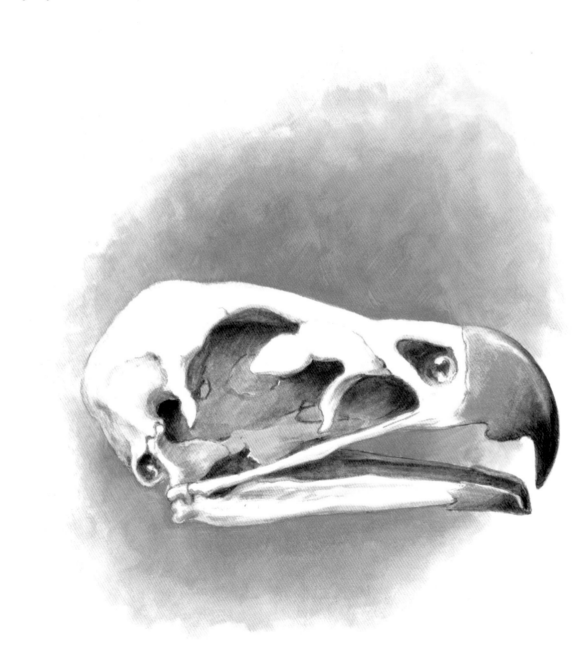

Left: Skull of Wedge-tailed Eagle, *Aquila audax.*

Right: Skeleton of Yellow-tailed Black Cockatoo, *Calyptorhynchus funereus,* and *Homo sapiens.*

Anatomy of birds (for the artist)

Much has been written on the subject of bird anatomy. Fortunately, for the purpose of drawing and painting birds, only some basics of anatomy need to be understood by the artist. It is possible that you just wish to draw and paint birds and are not really interested in learning about their structure. If this is the case, I doubt that you will ever paint birds well. To do so, you need to be prepared to put a little effort into understanding your subject. Quite often, even a very good photograph does not show you what you need to know, and so, an artist without anatomical knowledge who is working solely from a photograph tends to use guesswork and often gets it wrong. These mistakes are usually obvious to those who really know birds.

Skeleton

It is a great advantage to know what is under the feathers you are painting to understand what creates the lumps and bumps that determine the shape. A bird's skeleton is not that much different from our own when you look closely at it (left). Comparing our own structure with that of the bird allows you to understand where and how the shoulders should be and how the wings bend in the same places as our arms do. Knowing the skeleton also helps when positioning the legs on your drawing: it is important that they emerge from the body in the correct place.

Feathers

Most of what you draw or paint will be feathers. Naturally, different feather groups are often different shapes and forms and there seems to be no end to the variety, so it is essential that you study carefully the feathers of the particular species you are drawing. Get to know the groups of feathers that are present on most birds: ear coverts, wing coverts, primaries, secondaries, scapulars, and so on (see pp. 28 and 29). I cannot stress enough a need for an understanding of these feather groups and how they relate to each other. Study them until you are able to do a quick sketch of a bird outlining all the groups. *Only when you can do this will you be able to draw quickly from an observation of a moving bird.*

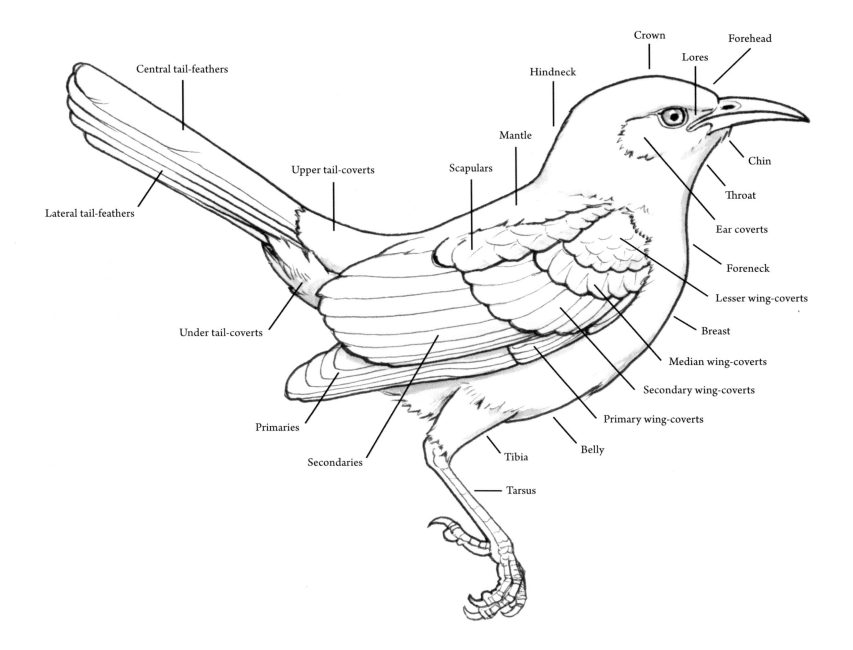

Central tail-feathers

Upper tail-coverts

Lateral tail-feathers

Under tail-coverts

Primaries

Secondaries

Scapulars

Mantle

Hindneck

Crown

Lores

Forehead

Chin

Throat

Ear coverts

Foreneck

Lesser wing-coverts

Breast

Median wing-coverts

Secondary wing-coverts

Primary wing-coverts

Belly

Tibia

Tarsus

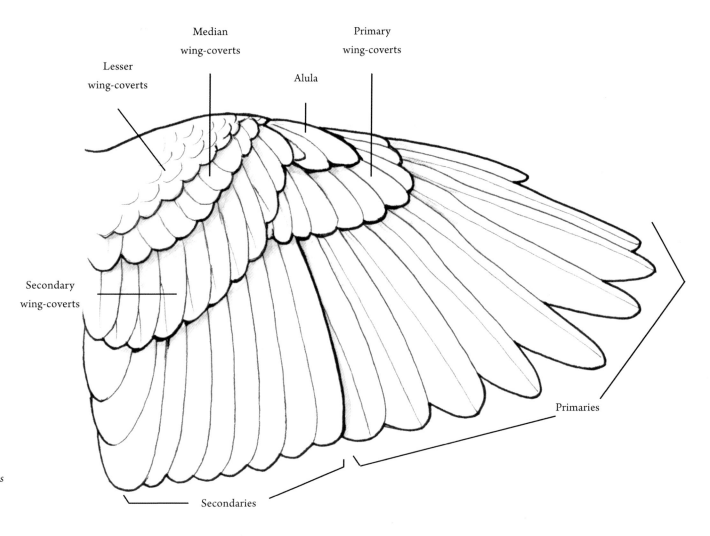

Median
wing-coverts

Primary
wing-coverts

Lesser
wing-coverts

Alula

Secondary
wing-coverts

Primaries

Secondaries

Left: Topography of a bird.
Grey-crowned Babbler, *Pomatostomus
temporalis,* showing the main
feather groups.

Right: Wing of Figbird, *Sphecotheres
viridis,* showing feathers of wing
when open.

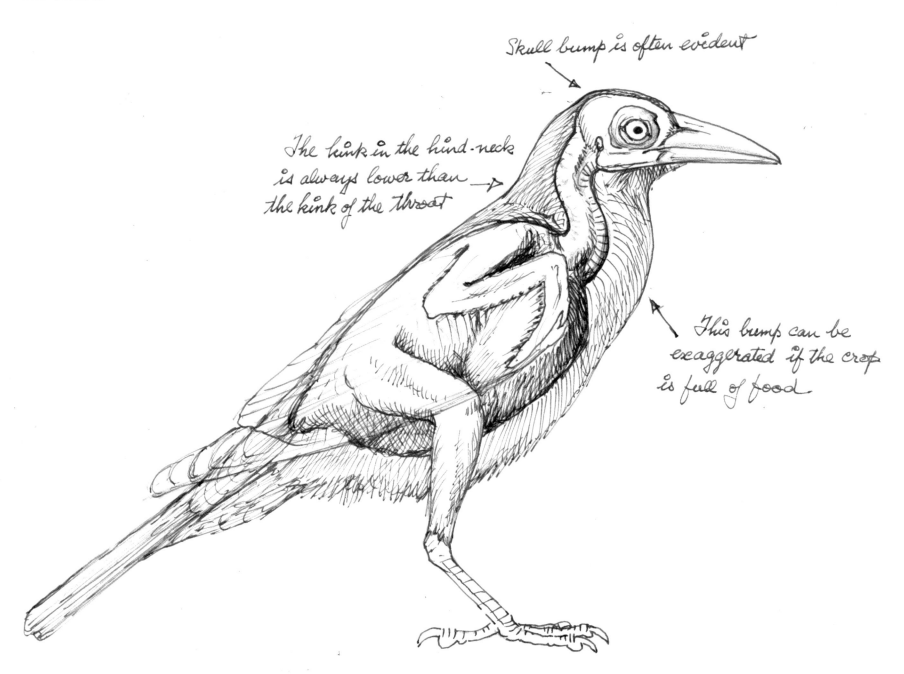

Skull bump is often evident

The kink in the hind-neck
is always lower than
the kink of the throat

This bump can be
exaggerated if the crop
is full of food

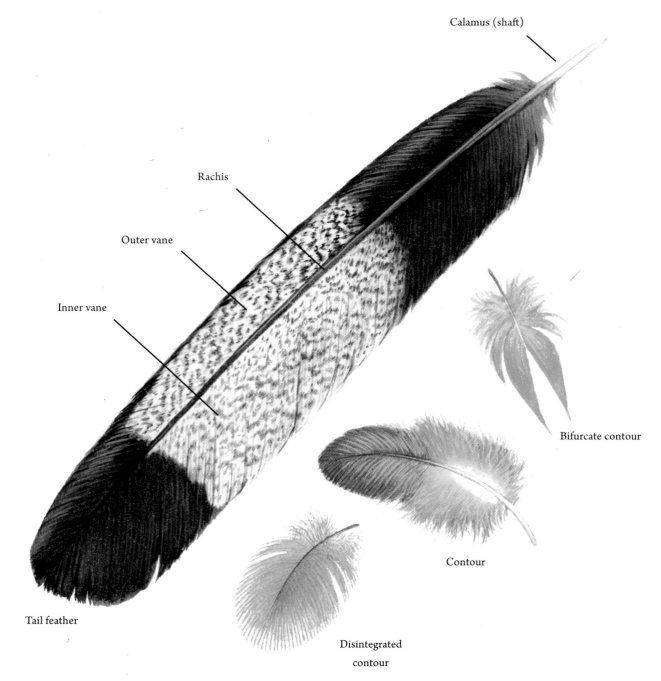

Calamus (shaft)

Rachis

Outer vane

Inner vane

Bifurcate contour

Contour

Tail feather

Disintegrated
contour

Left: Pied Currawong, *Strepera graculina*. This drawing demonstrates how much the external appearance of a bird is reliant on the feathers to make the shape of a bird as we see it.

Right: Some feather types and structures.

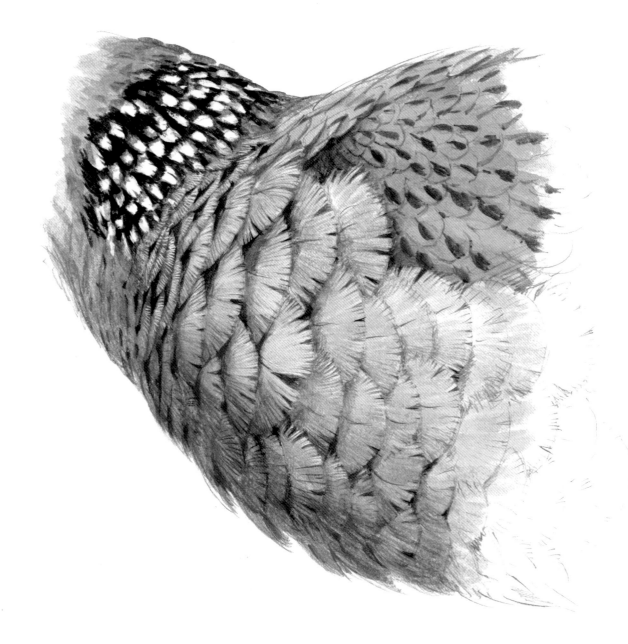

Left: A bird that is preening or sunbathing often fluffs out the breast feathers. The change of direction causes foreshortening of the feathers and pockets of shadow between them. This gradually diminishes to where the feathers are not opened.

Right: Emerald Dove, *Chalcophaps indica*, to show how feather groups overlay others.

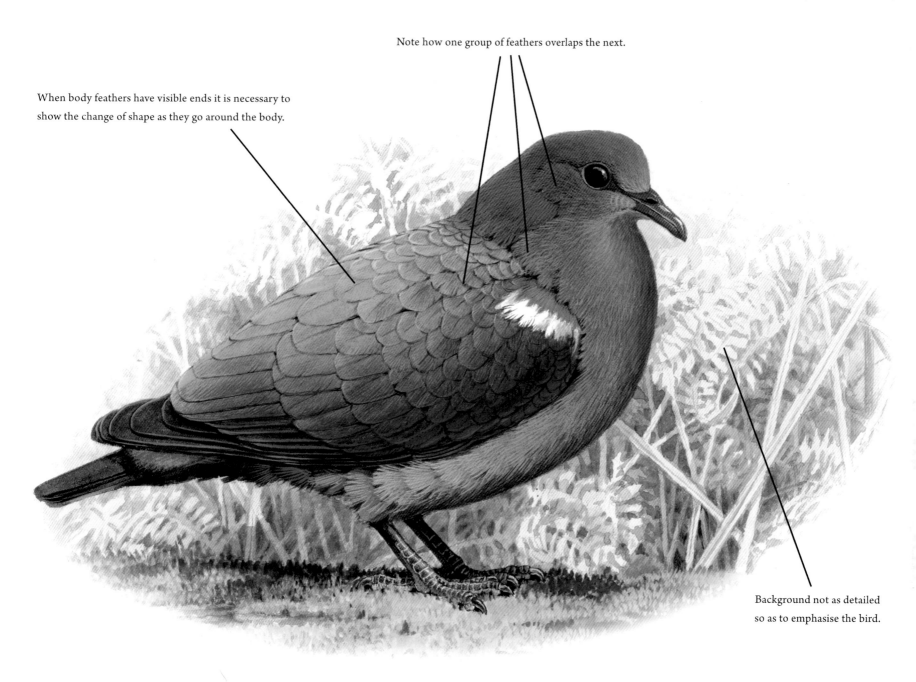

Note how one group of feathers overlaps the next.

When body feathers have visible ends it is necessary to show the change of shape as they go around the body.

Background not as detailed so as to emphasise the bird.

Feather tracts on skin

Feathers are not distributed evenly over a bird. They are in tracts with bare skin between them. As a bird moves its body, these groups of feathers often become apparent as one group moves away from, or over, another. Most of the groups overlap in a very specific way and sometimes the pattern of overlap differs between families. Note in the illustration on page 29 how the median wing-coverts overlap in the opposite direction to the secondary wing-coverts, secondaries and primaries. However, this does not occur in pigeons and cuckoos and some other groups of birds.

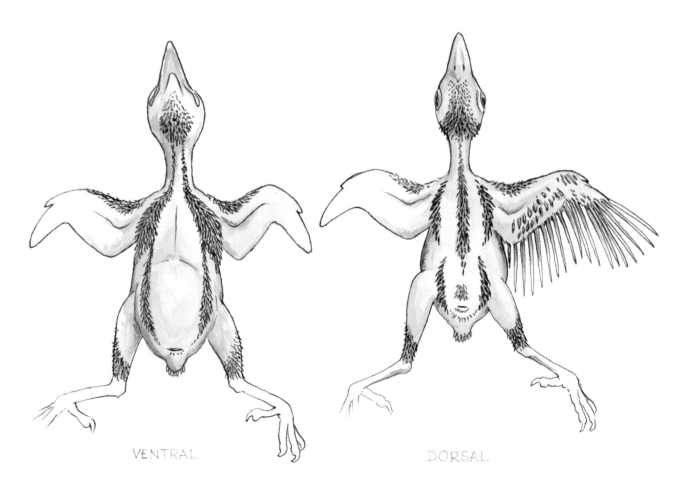

VENTRAL

DORSAL

Left: Fledgling Victoria's Riflebird, *Ptiloris victoriae*, showing ventral and dorsal feather tracts.

Right: Tail of Wompoo Fruit-Dove, *Ptilinopus magnificus*, as an example of how upper tail-coverts overlap the opposite way to the tail-feathers; also note how the **rachis** is located in the centre of the central tail feather and progressively nearer the outer edge towards the outer edge of the tail.

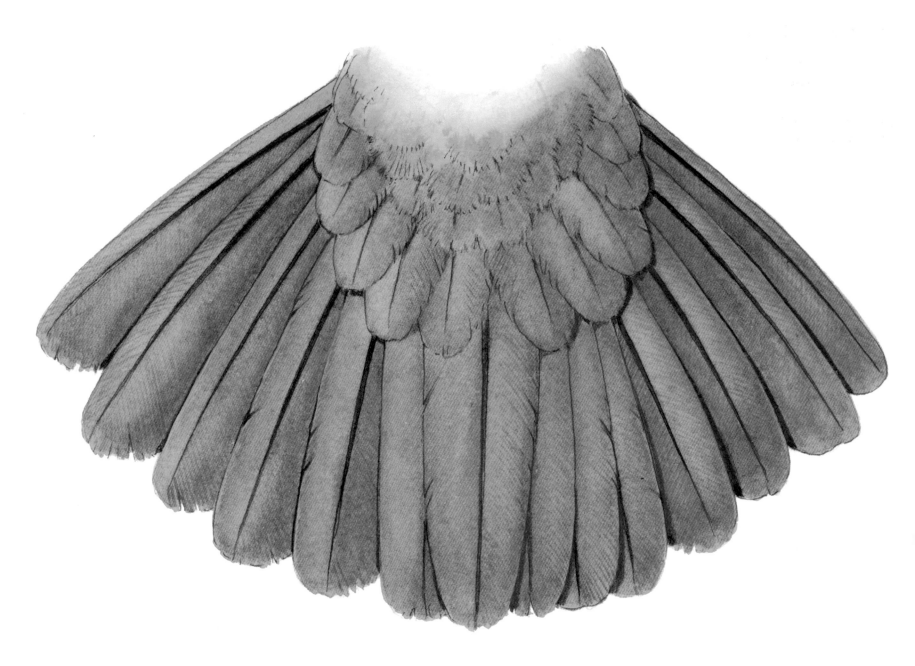

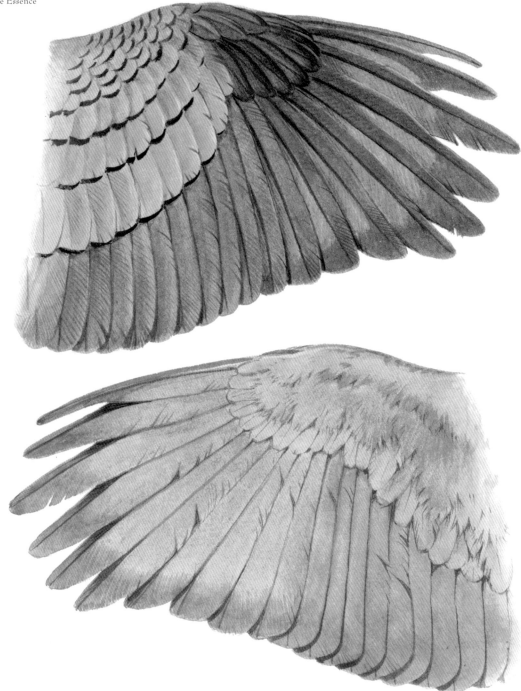

Left: (top) The upper and **(bottom)** under wing of a Bar-shouldered Dove, *Geopelia humeralis*. The number of primaries, secondaries and tail-feathers is usually consistent within each bird family. For instance, parrots have ten primaries, nine or ten secondaries and twelve tail-feathers. Kingfishers have ten or eleven primaries, eight to eleven secondaries and twelve tail-feathers. Of course, your illustration does not need to show every feather because most of the time on a bird some feathers are hidden under others. It is when you wish to show an open wing or a fanned tail that these numbers become most important.

Right: (top) Spotted Nightjar, *Eurostopodus argus*, and **(bottom)** Australian Logrunner, *Orthonyx temminckii*: a comparison of two very different wing shapes. The long wing of a nightjar has the primaries extending far beyond the secondaries when the wing is closed. In contrast, the short wing of a logrunner shows hardly any primaries beyond the secondaries when closed.

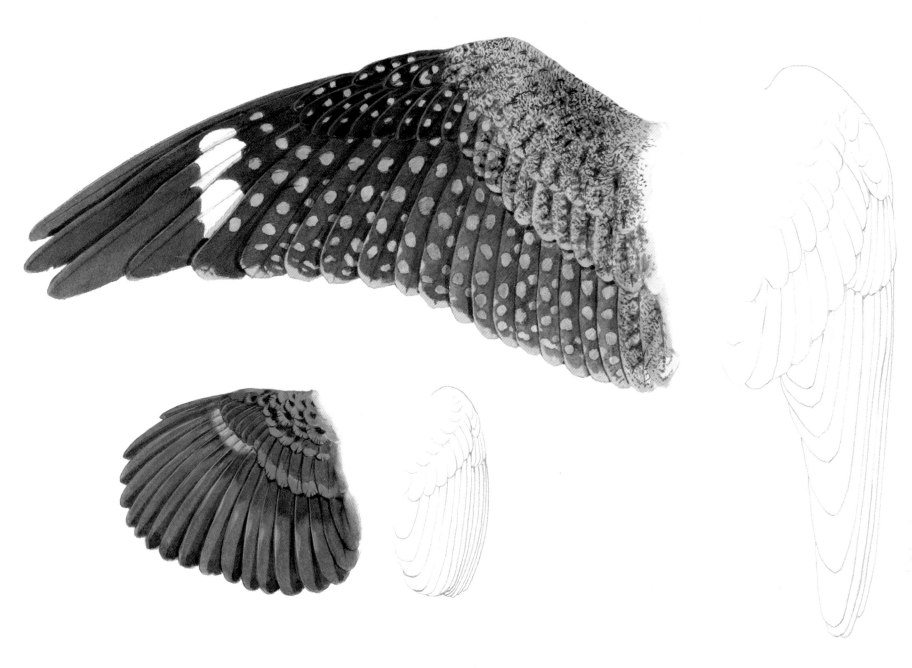

Feet

Just after my first book *A Portfolio of Australian Birds* was published, I happened to be at the Australian Museum when the wonderful British bird artist David Reid-Henry was also visiting. He was kind enough to compliment me on my work, but he did give me some very sound advice: 'Get the feet right, it is most important that the feet are given proper attention, as a very well painted bird can be spoiled by badly drawn feet'. I later checked the feet in his paintings in *The History of the Birds of Britain* and his famous birds of prey in *Eagles, Hawks & Falcons of the World* by Brown and Amadon. They were, of course, so much better than my first efforts. Feet are very important and can be difficult to draw. You need to be sure that they are grasping the branch convincingly or are placed correctly on the ground.

Feet, like bills, have evolved to serve many very different purposes including climbing, perching, running, digging, clinging and swimming.

The proportions of the feet to the rest of the bird are very important. A common error when drawing feet is to make them too small. A good way of checking this is to measure the longest toe and compare it with the length of the bill. Because feet are often wrapped around a twig or branch, they tend to appear smaller than they really are.

The numbers of toes and their arrangement can differ greatly between families and the scales may be arranged differently on certain species. Some species have no definition of the scales on the **tarsus**, whereas others may be very well defined. Most passerine birds have the scales clustered close together on the joints of the toes, whereas those on pigeons, for example, are almost evenly spread along the toes.

Passerines are birds of the order Passeriformes, which contains more than half of the world's birds. They are mostly perching and singing birds, but the feature common to all passerines is the structure of the foot. There are four toes all at the same level, with three pointing forward and one backwards, enabling them to perch comfortably on even the thinnest twigs.

All other birds are referred to as non-passerines, in which you find many different functional modifications to the feet. However, some non-passerines also have three toes pointing forwards and one backwards. The first toe is to the rear and has two joints. The second is on the inside front with three joints. The third is the centre front with four joints and the fourth is on the outside of the front and has five joints.

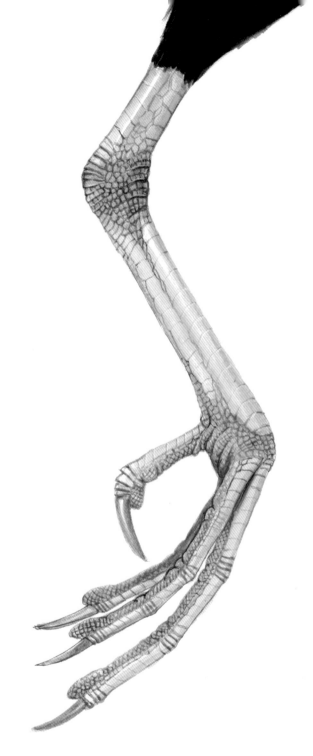

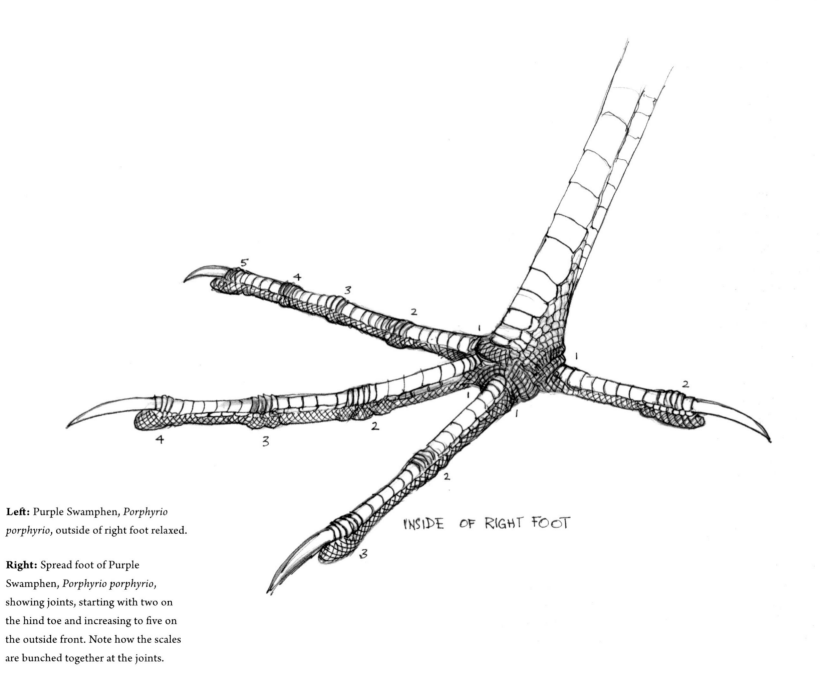

INSIDE OF RIGHT FOOT

Left: Purple Swamphen, *Porphyrio porphyrio*, outside of right foot relaxed.

Right: Spread foot of Purple Swamphen, *Porphyrio porphyrio*, showing joints, starting with two on the hind toe and increasing to five on the outside front. Note how the scales are bunched together at the joints.

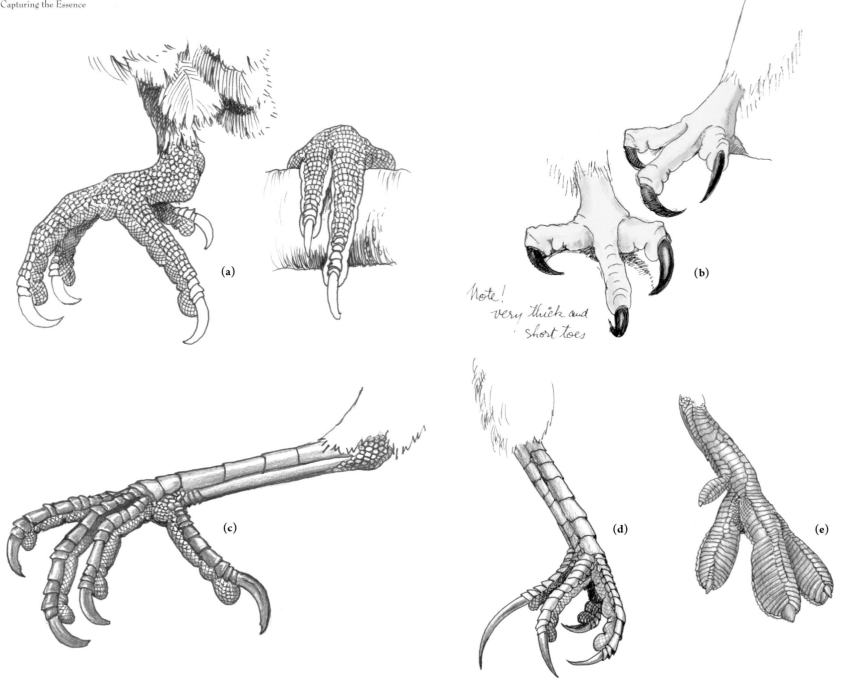

(a)

(b)

Note!
very thick and
short toes

(c)

(d)

(e)

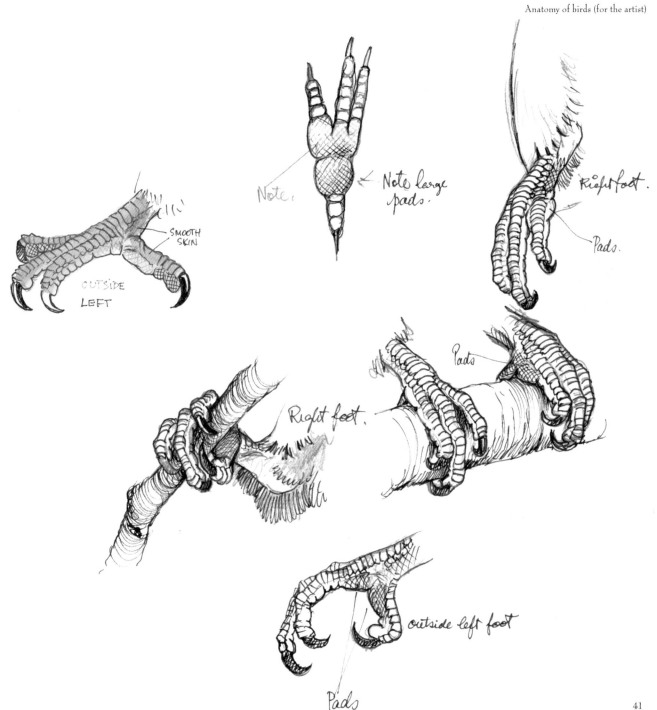

Left: (a) Red-tailed Black-Cockatoo,
Calyptorhynchus banksii. Typical parrot
foot; the left foot from the outside and
front showing two toes forward and
two back. **(b)** Black-shouldered Kite,
Elanus axillaris. Typical feet for
grasping and killing. **(c)** Raven,
Corvus coronoides. A typical Passerine
foot showing the inside of the right
foot. **(d)** Pheasant Coucal, *Centropus
phasianinus*, with two toes forward
and two back: an example of a
cuckoo's foot. **(e)** Australasian Grebe,
Tachybaptus novaehollandiae, showing
the flattened lobed toes of grebes that
are perfectly adapted for swimming.

Right: Wompoo Fruit-Dove, *Ptilinopus
magnificus*. These drawings show
clearly the joints and also the mostly
even spacing of the scales.

Bills (and gape positions)

Bills (beaks) come in an amazing array of shapes and sizes to suit particular functions such as spearing prey, cracking open nuts, catching small insects or ripping flesh, to name a few.

As with drawing the feet of birds, it is very important that you get the proportions of the bill correct and also the relationship of the bill to the head. Make sure that the taper is not too sharp or that the line between the gape and the tip, if arched, has the right amount of curve and that the top of the curve is at the correct distance from the **gape** to the tip – a millimetre can make all the difference. Getting the bill right is critical to capturing facial 'expression'. The next most important task is to get the bill's position correct in relation to the eye. The difference in position of the 'gape to eye' on a snipe compared with a cormorant represents two extremes (see opposite).

When painting the shine on a bill, the position is governed by the source of light evident in the whole picture. The shine is towards the top if the light comes from above and more down the side when the source is from a lower angle. Look for grooves or bumps on bills that would catch the light and help to give detail or shape.

Left: Head of Australian raven, *Corvus coronoides*, to show parts of the bill.

Right: Some examples of the variation in bills. Note how the gape on the cormorant passes well back past the eye, whereas the gape on a snipe is quite a distance in front of the eye. The distance of the gape from the eye is important when it comes to capturing the facial expression of a bird. **(a)** Great Blue Heron, *Ardea herodias*; **(b)** Cape Barren Goose, *Cereopsis novaehollandiae*; **(c)** Toco Toucan, *Ramphastos toco*; **(d)** Blue and Yellow Macaw, *Ara ararauna*; **(e)** Latham's Snipe, *Gallinago hardwickii*; **(f)** Gouldian Finch, *Erythrura gouldiae*; **(g)** Laughing Kookaburra, *Dacelo novaeguineae*; **(h)** Wedge-tailed Eagle, *Aquila audax*; **(i)** Bassian Thrush, *Zoothera lunulata*; **(j)** Pacific Black Duck, *Anas superciliosa*; **(k)** Great Cormorant, *Phalacrocorax carbo*; **(l)** Turtle Dove, *Streptopelia turtur*; **(m)** Ringneck Pheasant, *Phasianus colchicus*.

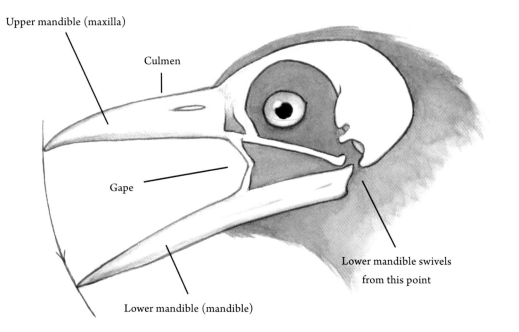

Upper mandible (maxilla)

Culmen

Gape

Lower mandible (mandible)

Lower mandible swivels from this point

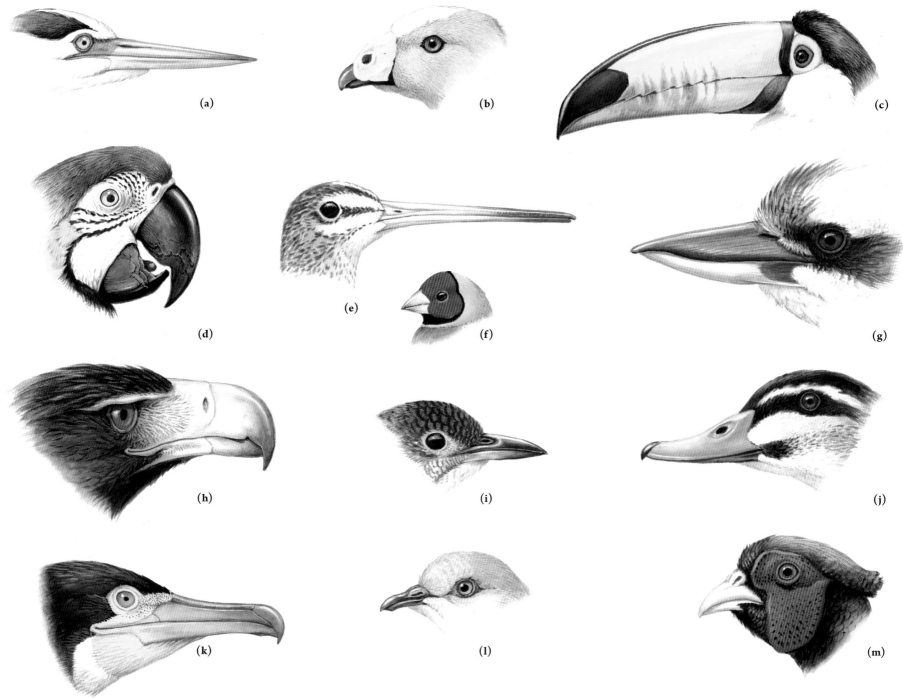

Eyes

Whether or not your drawing or painting of a bird has life and expression depends greatly on how well you depict the eye. The position of the highlight on the eye is governed by the direction of the light source: it is high on the eye if the sun is high in the sky and more towards the centre of the eye if the sun is low. The highlight is often just a white spot, or a white spot with a suggestion of sky adjoining it. If the eye is in the shade then there is no white highlight, but a dull grey-blue, which is more or less the top half of the eye, and the dark below is a reflection of the horizon and what is below it. Be sure that the highlight is in the correct position in relation to the light source for the rest of the picture. Paintings showing two white spots in the eye are actually showing the reflection of two spotlights in the photo from which it was referenced. On the extreme outer edge of the eye there is usually a very fine dark line defining the separation of the eyelid from the eye (see top right).

Eyes are not always round in shape. Only when the bird is at right angles to the viewer are the eyes round. There are some species in which the eye is slightly elongated and there are birds such as eagles that have their eyes half-turned towards the front and so, when the head is at right angles to the viewer, the eye shape appears to be more vertical (see p. 43h).

In some species males, females and juveniles have different coloured eyes.

When a bird is excited or frightened, the pupil can contract and be much smaller than when the bird is at ease. In some species, the pupil can reduce to the size of a pinhead. The pupil also becomes larger in shade and smaller when in sunlight. As with bills, the slightest change in size or shape can cause an eye to appear right or wrong.

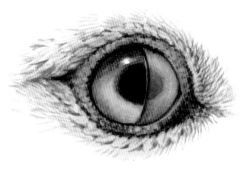

Above: Birds have a third eyelid, called a nictitating membrane, which is almost clear and protects the eye when the bird is landing among thick foliage or grass stems, and so on. It is not normally visible because it retracts back into the front lower corner out of sight behind the main eyelids. The nictitating membrane often shows when a bird is preening and can sometimes be seen when a bird is dozing.

Far left: (top) The progression from the first wash of pale yellow laid down leaving a spot of white paper where the light will fall, to the finished eye.

Far left: (bottom) Progression from the first brown wash to the finished eye.

Left: (top) Example of a brown eye in shade.

Left: (bottom) Example of a black eye in shade.

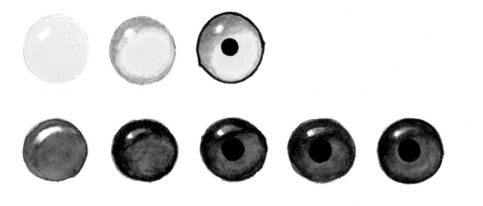

Sketching from life

Sketching in the zoo – captive or tame birds

The longer you study a bird, the more you will see how it is 'put together', and the more chance you have of drawing a good likeness.

You can draw directly from the live bird or, before attempting the life drawing, find some photographs and draw from them repeatedly until you feel you have gained some knowledge of the bird's structure and patterns. This will save you time when you begin drawing the live bird. It will allow you to sketch more quickly and confidently. When you think you have done some good sketches, check them against the live bird and make corrections.

Generally, birds do not sit still long enough for you to draw them and so you must develop the skill of getting as much on paper as you can before the bird moves, and then starting a new sketch of the next posture it assumes. Eventually the paper will be covered with bits and pieces of the bird from all angles. If you cannot see the head, don't worry: draw some details of the foot that you can see, or the tail or whatever presents itself. All of these 'part birds' will eventually allow you to draw the whole bird, and you certainly should have learned a lot about its structure and appearance in the process.

Naturally, different artists have different methods or ideas of how to work from life. I find that building the sketch around two ovals or circles – which accommodate the head and body – is the easiest for a bird in profile. Lightly draw two circles or ovals, noting the relative size of the head to body because it varies greatly (see p. 47d). Relative to its body size, the head of a pigeon is small, whereas a fairy-wren's head can appear almost as large as the body, depending on its posture.

When drawing the wings on your body shape, take note whether they fold above the rump, as in most birds, or at the sides of the rump, as in most pigeons or quails (see p. 47a,b). Note also how far the primaries extend beyond the secondaries, if at all. Check the comparative length of the tail and mark it down. All of this is done very quickly without attention to detail and is all subject to correction as the drawing progresses. .

Note the areas of the head and draw them roughly into your 'head circle'. Take care when adding the legs, so that they emerge from the 'body circle' in the correct place and that the bird is balanced on them. The subject only has to change position a little to make the legs appear to come from a different place at a different angle, although the feet will still be at a point of balance (see p. 47c). It is important that the feet are at the centre of gravity, otherwise your bird will look as though it is falling over.

If, while you are sketching, the bird drastically changes position, don't wait for it to come back to the sketch position (it may never do it!) – start another sketch.

Below: (top) White Quilled Rock-Pigeon, *Petrophassa albipennis*, and **(bottom)** Superb Fairy-wren, *Malurus cyaneus*, showing head to body size.

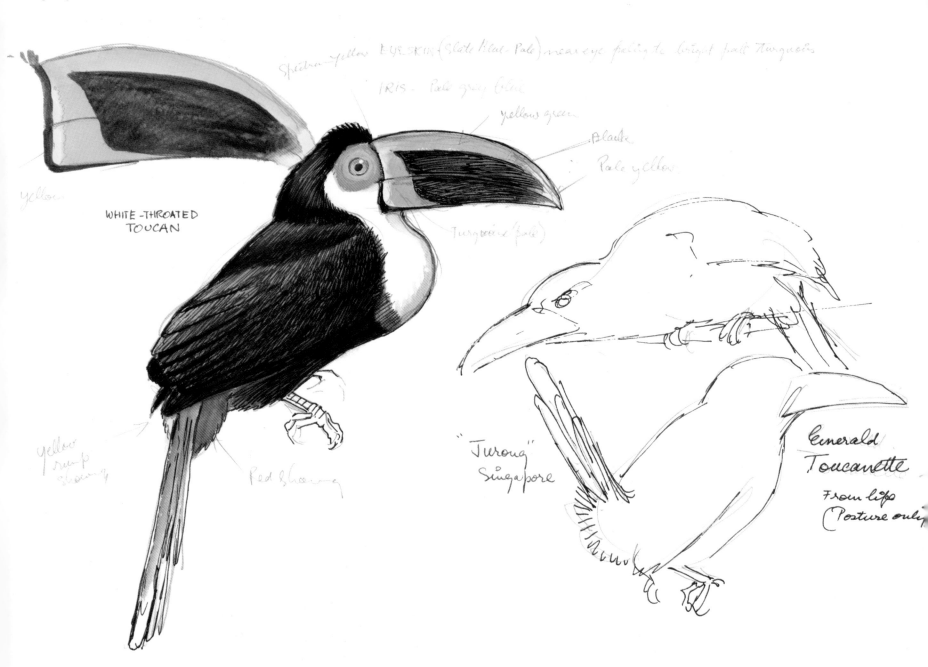

Spectrum yellow EYE SKIN (Slate Blue-Pale) near eye passing to bright pale Turquoise

IRIS - Pale grey blue

yellow green

Black

Pale yellow

Turquoise (pale)

Yellow

WHITE-THROATED
TOUCAN

yellow
rump
showing

Red showing

"Jurong"
Singapore

Emerald
Toucanette

From life
(Posture only

Left: White-throated Toucan, *Ramphastos tucanus*. Drawn from a captive bird at a bird-park.

Right: (a) Example of wings folded by the side. (b) Example of wings folded over the rump. (c) Ducks balance. Pacific Black Duck, *Anas superciliosa*, to show the centre of gravity as the bird changes position. (d) Masked Finch, *Poephila personata*. The head and body circles – the absolute start of these drawings – have not been rubbed out and are still evident. These sketches were done after long observation of the birds in the field.

Let us assume that you have been successful so far and you have some basic shapes and postures. Then you should turn your attention to the feather groups and their relationship to each other. Look for the comparative lengths of the different feather groups of the wing – they can vary greatly between species.

Because you are drawing from a captive bird, you have time to check details of eye position, bill, gape, feet, and so on and to make colour notes (e.g. see pp. 46, 48–50). This is not so easy in the field.

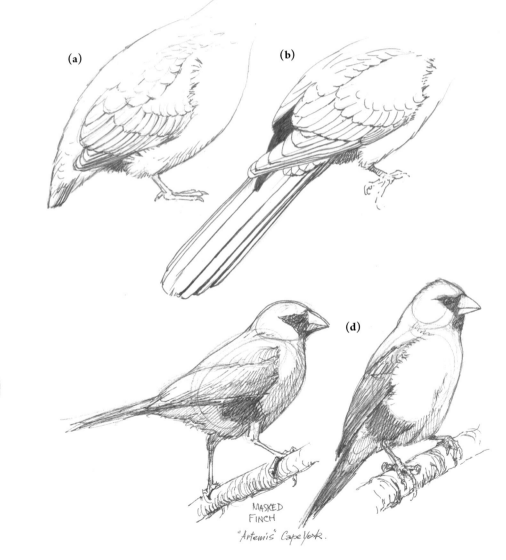

(a)

(b)

(c)

(d)

MASKED FINCH

"Artemis" Cape York.

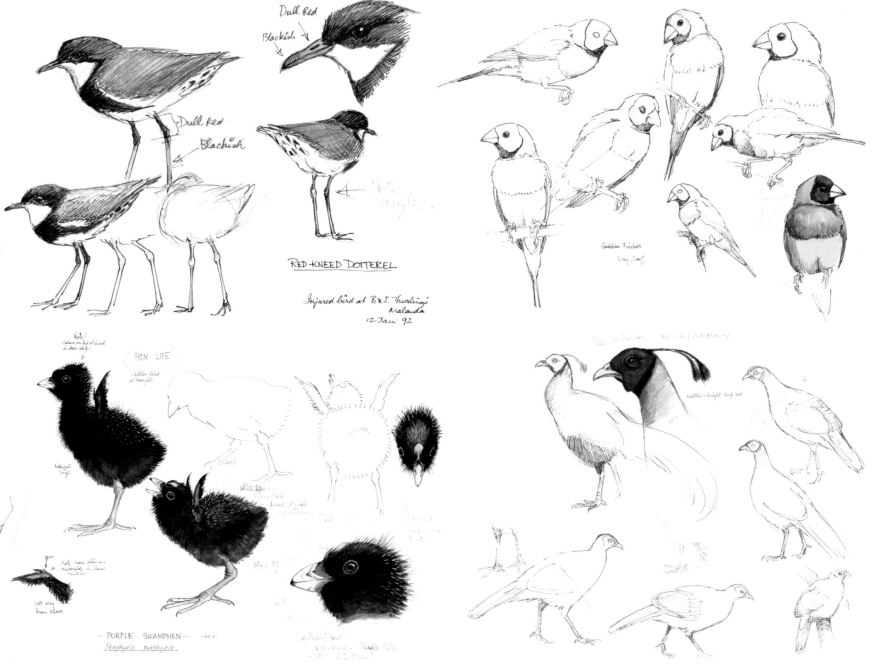

Dull Red
Blackish

Dull Red

Blackish

Dull Red
Blackish

RED-KNEED DOTTEREL

Injured bird at B.& J. Thurling's
Malanda
12-Jan '92

Gouldian Finches
May 2007.

FROM LIFE

— PURPLE SWAMPHEN — CHICK.
Porphyrio porphyrio.

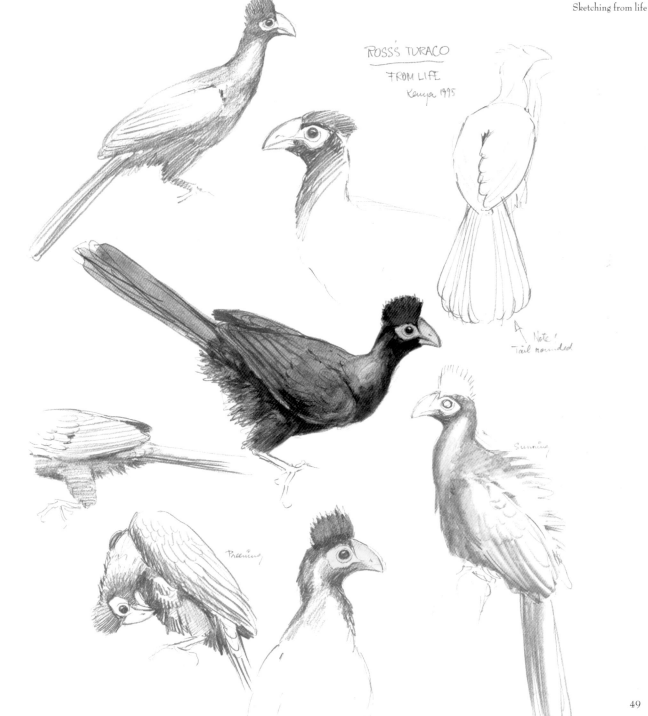

ROSS'S TURACO
FROM LIFE
Kenya 1995

Note
Tail rounded

Sunning

Preening

Far left: (top) Red-kneed Dotterel, *Erythrogonys cinctus*. These sketches drawn from a captive bird capture the jizz, which would be impossible from a museum skin.

Far left: (bottom) Purple Swamphen chick, *Porphyrio porphyrio*. These sketches were done from an orphan bird that was being reared by a friend. Notice how large the feet are compared with the size of the body. Many more postures than these were drawn in preparation for a future painting of a swamphen family.

Left: (top) Gouldian Finch, *Erythrura gouldiae*. Captive birds allow close scrutiny, although due to diet, their colours are often faded and not as bright as those of wild birds. The colour in this case is added from observations of birds in the wild.

Left: (bottom) Siamese Fireback Pheasant, *Lophura diardi*. Some of many sketches done from captive bird.

Right: Ross's Turaco, *Musophaga rossae*. These sketches were done in Kenya from captive and wild birds for a book *The Turacos*.

49

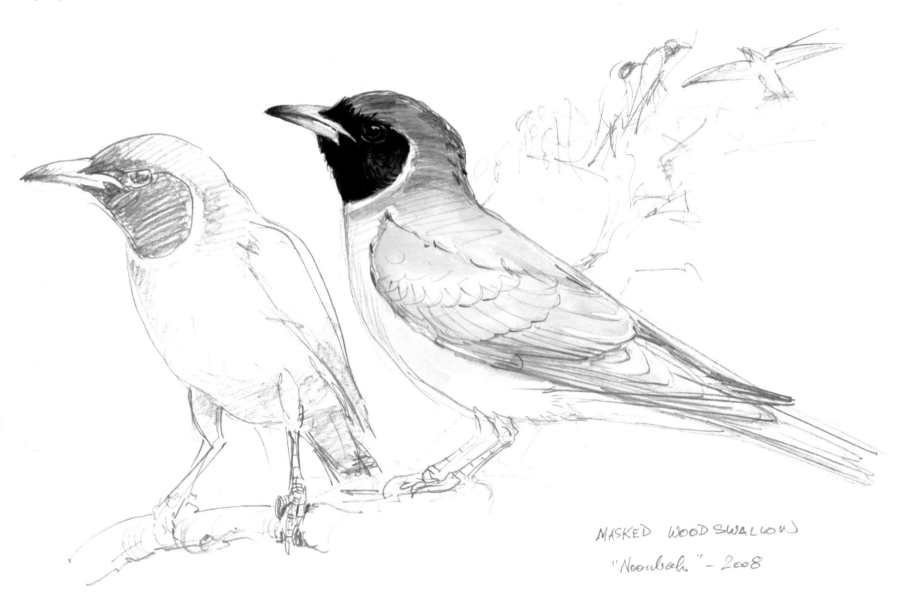

MASKED WOODSWALLOW

"Noonbah" - 2008

Sketching in the field

When sketching in the field, anything bigger than an A3 pad becomes awkward to use. Binoculars are essential for studying birds in the wild. Birds that are moving about feeding, hopping from branch to branch, and so on, allow little time for sketching, and they will usually have disappeared by the time you look up from your drawing. So, whenever you can watch the bird, do so, looking for the overall shape and getting it stored in your mind. Then study the feather groups and how they relate to each other, and as much other detail as you can while the bird is in sight. As soon as the bird has gone, sketch quickly from your 'mind picture'. This is where knowing the feather groups is imperative and will enable you to piece together what has been retained in your 'mental photograph' of the bird. Don't expect great results the first time you try this – it does take a lot of practice.

To assist in developing your 'mind picture', perhaps having a method of observation would help. First, take in the overall shape of the head and body, and relativity of the head to the body, body to tail, and so on. Then, as parts of the bird present themselves, take advantage of this to add to your mental image. If the legs are visible, look at the proportions and whether the bird squats or stands on them. The bill and eye should be looked at together because their relative positions are essential to get the correct 'expression'. This is how we see other people – we know them by their face – and so it is with birds. It is impossible to have a system or an order in which these observations are made because the bird is constantly moving about.

With this described method, you are drawing from memory immediately after having studied the bird. Needless to say, the more practice you have at using this method, the better you become at holding the mental image from which you draw, and the quicker and more confident you become. The results, of course, need to be checked and adjusted against some sort of reference material. It is good practice to date and record location on your sketches and make colour notes in the margin.

Using binoculars from a 'hide' gives you excellent close-up views of your subject and a chance to make lots of sketches. Setting up a 'hide' near a nest, as bird photographers do, is a great way to get good views of the bird. See page 16 for more on hides.

When birds are feeding young is a good time to be drawing because the birds keep returning to the nest, giving you a chance each time to correct or finish a drawing from the previous visit. Make notes on the colour of the eyes, bill, feet and any soft parts such as skin around the eyes or wattles. Note whether the male is different from the female. All this information is important when you are painting, and is more reliable when done from the live bird rather than from photographic references.

Above: Magpie Goose, *Anseranas semipalmata*. Extremely quick sketches to catch postures when the only tools to hand were a borrowed biro and a notepad.

Left: Masked Woodswallows, *Artamus personatus*. Sketches from life with colour added later in the studio.

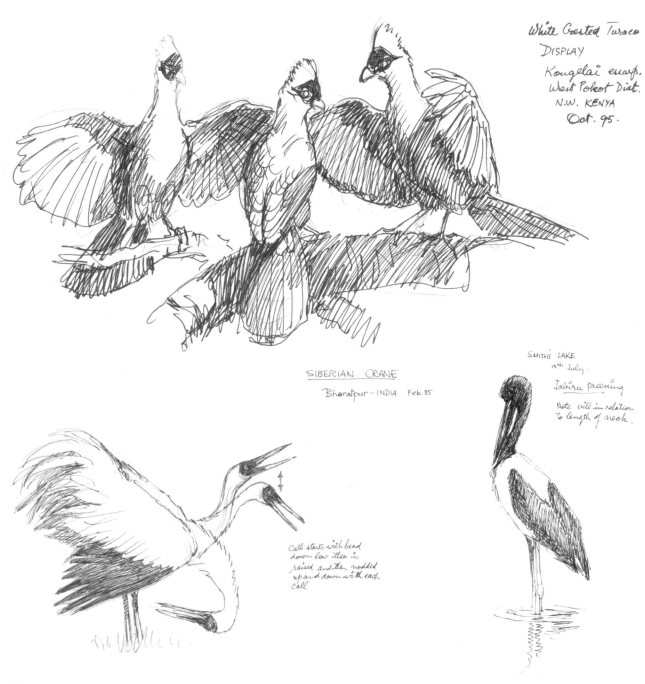

White Crested Turaco
DISPLAY
Kongelai escarp.
West Pokot Dist.
N.W. KENYA
Oct. 95.

SIBERIAN CRANE
Bharatpur – INDIA Feb. 85

Call starts with head
down low then is
raised and then nodded
up and down with each
call

SMITHS LAKE
19th July.
Jabiru preening
Note bill in relation
to length of neck.

Left: (top) White-crested Turaco, *Tauraco leucolophus*. This is a quick sketch done in the field immediately after watching two males displaying to a female. Later, a much-refined half-tone drawing was done and used as an illustration in *Turacos – A Natural History of the Musophagidae*.

Far left: (bottom) Siberian Crane, *Grus leucogeranus*. Field sketch from life to show the bowing action while the bird was calling.

Left: (bottom) Black-necked Stork, *Ephippiorhynchus asiaticus*. This sketch, although rough and quick, captured quite a lot of information.

Right: Chowchilla, *Orthonyx spaldingii*. This is a behavioural sketch done from life and finished from memory immediately after observations.

Far right: Regent Bowerbird, *Sericulus chrysocephalus*. These drawings were done taking advantage of a bird at ease, feeding in a fruiting tree for an extended period. The colour was added later.

CHOWCHILLA ♂ Calling — wings & tail spread — almost sunken into the leaves probably the depression in which he was scratching

REGENT BOWERBIRD
Sericulus chrysocephalus ♂

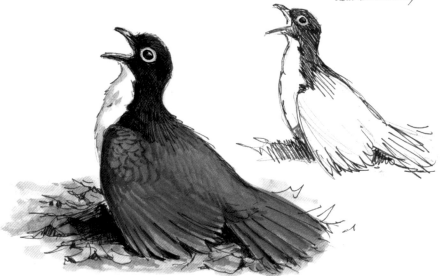

NOTE!!

Note!
RUMP & BACK
EXPOSED

2 Birds ♂ & ♀ Calling while perched 3 m up in a tree. Birds about 40 cm apart.
Male would call while ♀ made a few grating sounds. Spell; then ♀ would call while male made same soft grating or growling sounds or a series of sounds rather than a continuous one.
♂ & ♀ went on calling for about 5 minutes or more taking it in turns every time. There were answers from another bird / birds between each call of the birds I was watching.

Just before this calling duel there had been a scuffle on the ground right in front of us. The ♂ (of the pair I watched calling) chased off another bird (sec?)

← Note length of legs.

"Manooka"
BUNGWAHL — 16th Aug. 85
1100 hrs. — watched male sitting in Grev. robusta. It then flew to Polyscias beside the drive where it fed for 10 minutes or more on the fruits.
1130 hrs. — Bird left.

53

Other good places for drawing birds are birdbaths or feeding tables. Parks and gardens are ideal because most of the birds there are quite accustomed to people moving around them. Ducks on a pond are good subjects, and they are great to draw when they sit on the bank and preen. Even in these places, you will find that binoculars are useful for gathering detail.

Remember, the more you draw from life, the more you will get to know your subject and the better you know your subject, the better you will be able to draw from life.

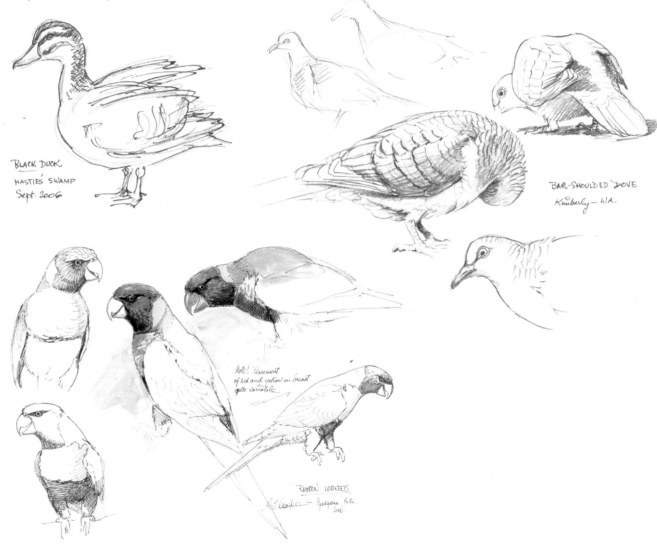

BLACK DUCK
HASTIES SWAMP
Sept. 2006

BAR-SHOULDED DOVE
Kimberly — W.A.

Note! Placement
of red and yellow on breast
quite variable

RAINBOW LORIKEETS

Far left: (top) Pacific Black Duck, *Anas superciliosa*. Ducks are good subjects, especially in parks and gardens where they are accustomed to people and allow close approach.

Left: (top) Bar-shouldered Dove, *Geopelia humeralis*. Only an intimate knowledge of the bird allows you to get this much detail from wild birds. It means that you can draw so much more quickly.

Left: (bottom) Rainbow Lorikeets, *Trichoglossus haematodus*. These birds become quite tame in urban environments and so give opportunities for more detailed sketches.

Right: Yellow-breasted Boatbill, *Machaerirhynchus flaviventer*. When sketching from life in the field, you must get down what you can and move to the next sketch when the bird moves, *or* roughly finish the sketch from your mind picture before moving on.

Far right: White-breasted Kingfisher, *Halcyon smyrnensis*. Sketches done from life on toned paper and coloured later. This bird was perched on a broken stem in the water from where it would dive for fish, always returning to the same perch. An ideal opportunity to do careful sketches.

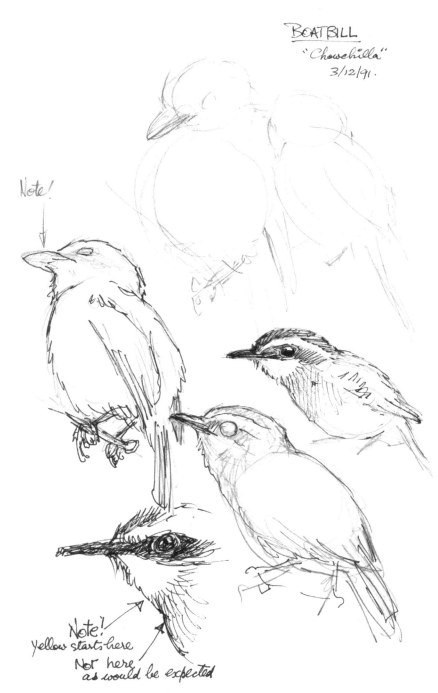

BOATBILL
"Chowchilla"
3/12/91.

Note!

Note!
yellow starts here

Not here
as would be expected

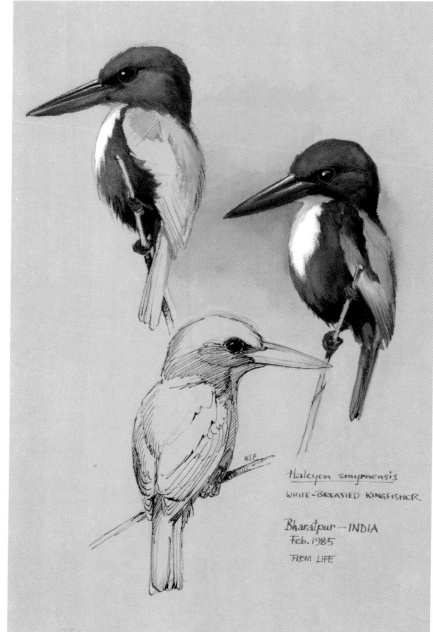

Halcyon smyrnensis
WHITE-BREASTED KINGFISHER

Bharatpur — INDIA
Feb. 1985
FROM LIFE

55

Birds in flight

Drawing birds in flight is rather difficult, takes time and requires a lot of observation. Some birds tend to lend themselves more to this subject simply because they soar, hover, glide or flap slowly, which means holding a position long enough for you to make quick sketches. It is preferable to begin with a species that stays around so that you have time to study it over and over. The image then remains clear when you put pencil to paper. Seagulls are perfect subjects on which to practise (see below).

Once again, knowledge of your subject is a great advantage when trying to draw a bird airborne. If you happen to have a stretched wing of the species you intend to work on, this will certainly be of some help, but usually not enough, unless you have observed the bird often and know it well.

Drawing a bird in flight sometimes requires technical assistance. For most species, it is almost imperative that you resort to photographs or videotape that can be played over and over to find the most attractive posture or the one that suits your intended painting. It is surprising how many frames will look awkward or ugly, but, eventually, by watching carefully again and again in slow motion, you will get to understand the bird in the air.

Some artists paint the ends of wings as a blur when painting a flying bird that is actively flapping rather than gliding. This does give a look of action and movement, but has to be done very well to be convincing.

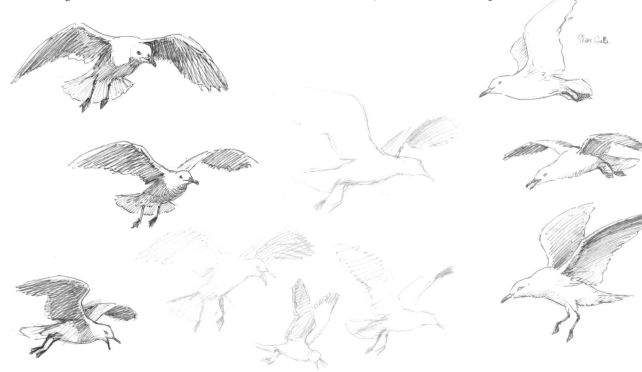

Silver Gulls.

Left: Silver Gull, *Chroicocephalus novaehollandiae*. Gulls are probably the best birds on which to practise sketching birds in flight because they are tolerant of people, particularly in places where they get fed. You will get plenty of chances to correct your sketches.

Right: (top) Cockatiel, *Nymphicus hollandicus*. These birds fly quite fast, so it is almost impossible to see the wing positions exactly. Videotape was used to capture these postures, but knowledge of the bird was also needed to be able to complete the sketches in detail.

Right: (bottom) Masked Lapwing, *Vanellus miles*. When sketching birds in flight, it helps greatly if you already have a good knowledge of bird's feathers. In this case, the shape of the wattles and the placement of the colours were also vital.

Far right: (top) Eastern Grey Plantain-eater, *Crinifer zonurus*. These are very quick sketches done while watching a pair of birds performing display flights.

Far right: (bottom) Brolga, *Grus rubicunda*, and Sarus Crane, *Grus antigone*. Large birds, such as these cranes that flap relatively slowly and intersperse flapping with gliding, are good subjects to sketch in flight.

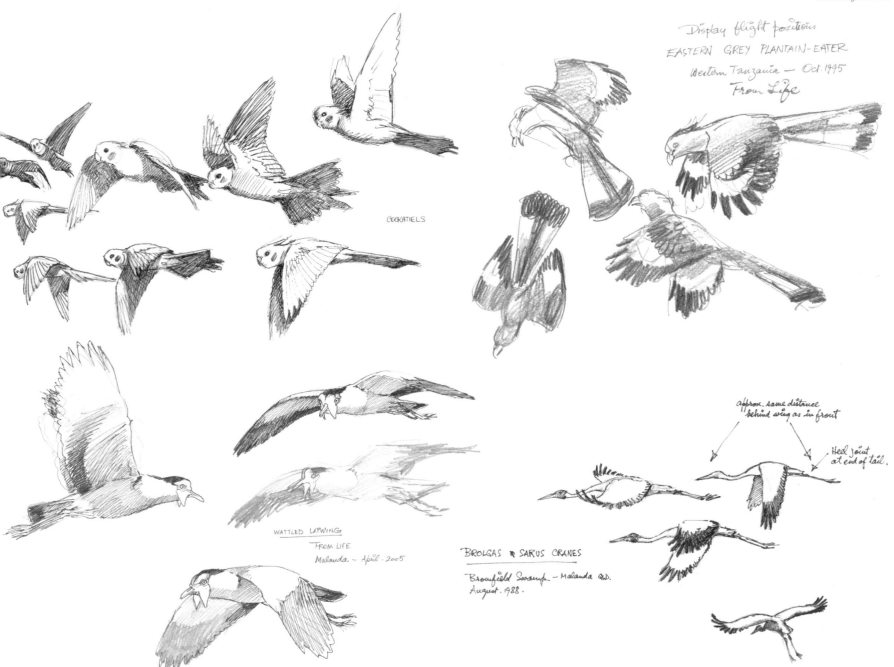

Display flight positions
EASTERN GREY PLANTAIN-EATER
Western Tanzania — Oct. 1995
From Life

COCKATIELS

approx. same distance
behind wing as in front

Heel joint
at end of tail.

WATTLED LAPWING
FROM LIFE
Malanda — April - 2005

BROLGAS & SARUS CRANES

Bromfield Swamp — Malanda Qld.
August. 1988.

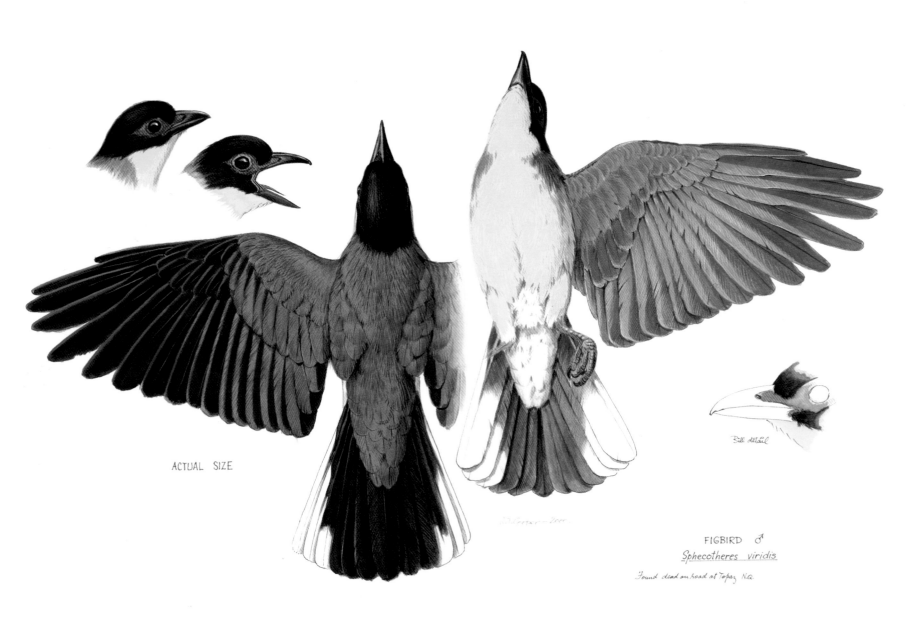

ACTUAL SIZE

Bill detail

FIGBIRD ♂
Sphecotheres viridis

Found dead on road at Topaz N.Q.

Measured drawings

Measured drawings are done by using callipers to accurately draw the bird life size. In my opinion, the master of the 'measured drawing' is the famous English artist C.F. Tunnicliffe who did drawings and paintings of any freshly dead bird he could get his hands on. He drew from above and below, with wing outstretched and closed, tail fanned, as well as bill and foot studies.

Anytime the fresh body of a dead bird should come your way, make a measured drawing. It does take time, and what you produce is not a finished painting – just a study of a bird – but it will be invaluable if you wish to do a painting of the species later. Another great benefit is how much you will learn about a particular bird.

If you happen to know someone who keeps birds in aviaries, it would be worthwhile mentioning to them your great desire to make good use of any birds that die.

These pages show some examples of my own measured drawings. They are, however, rather simple compared with Tunnicliffe's studies.

Left: Figbird, *Sphecotheres viridis*.

Right: Little Kingfisher, *Ceyx pusilla*.

Following spread: (left) Red-backed Kingfisher, *Todiramphus pyrrhopygia*.

Following spread: (right) Tree Martin, *Petrochelidon nigricans*.

LITTLE KINGFISHER
(*Alcyone pusilla*)

Flew into window & died at
Lake Tinaroo — 19th March 2002

W.T.C.

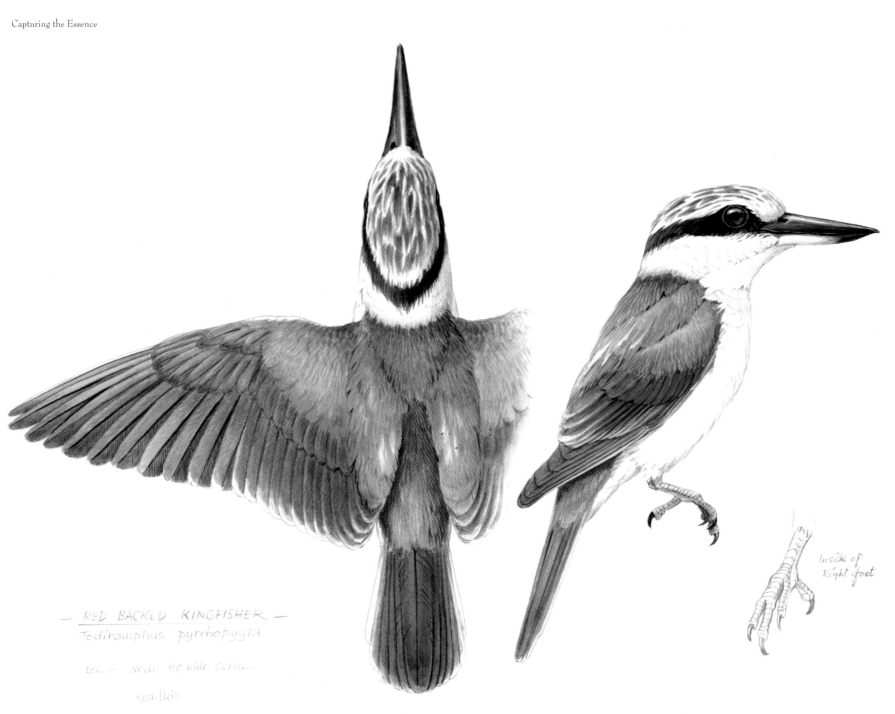

RED BACKED KINGFISHER —
Todiramphus pyrrhopygia

loc. — Near 40 mile Scrub

roadkill

Inside of
Right foot

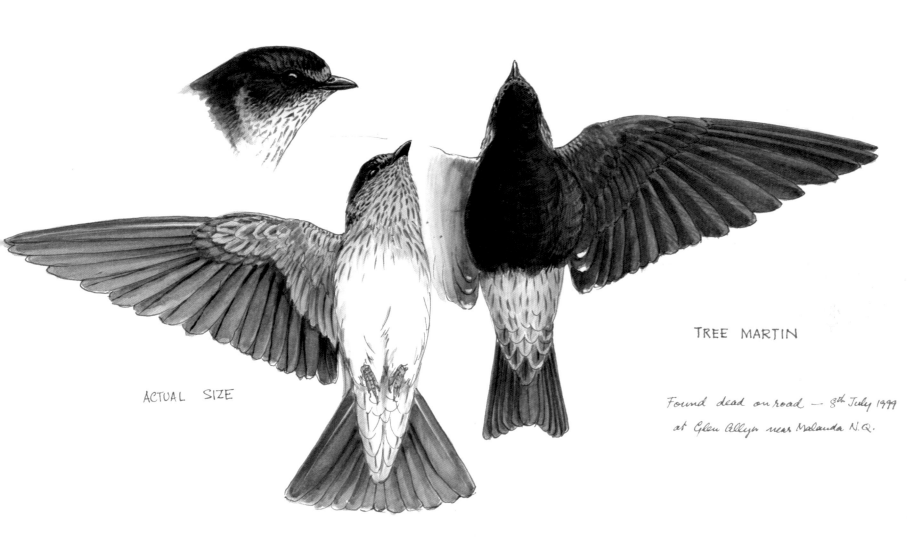

ACTUAL SIZE

TREE MARTIN

Found dead on road — 8th July 1999

at Glen Allyn near Malanda N.Q.

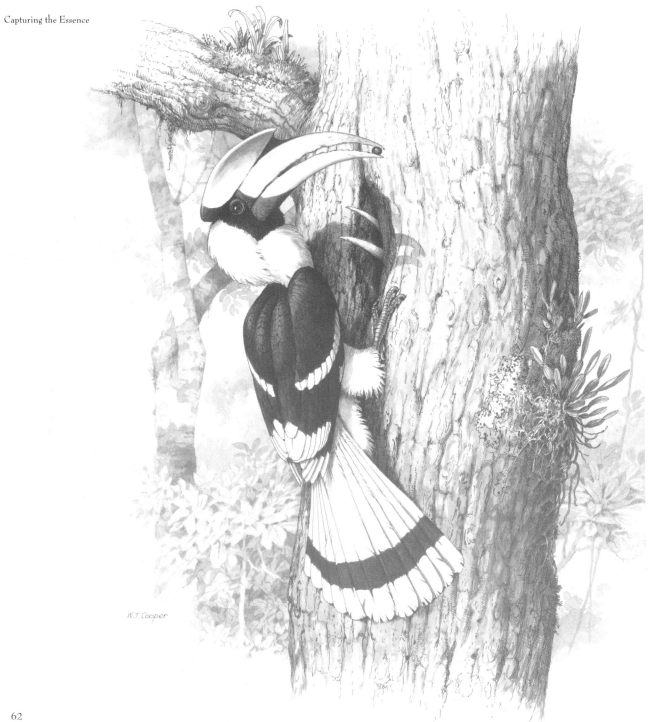

W.T.Cooper

Left: Great Hornbill, *Buceros bicornis*.
This behavioural drawing was published
in *Kingfishers and Related Birds*
written by Joseph M. Forshaw. It is an
example of pen and ink wash with the
background forest done in wash only.

Black and whites

Talent is overrated – there are thousands of people with talent and visual circuitry
– it's what you do with talent that counts. – DAVID LEFFEL

If you are not ready, or do not wish, to work in colour, then working in black and white (and greys) can be rewarding. Black and whites often fit nicely as extras into books that are predominantly in colour. Ordinary graphite pencils on their own can be quite effective, as can 'light-wash' graphite pencils, which can be shaded by using water on a brush making nice even greys with a watercolour appearance. Another effective method is to use 'pen and wash'. Using a waterproof ink, or one of the fibre tipped drawing pens (permanent and waterproof variety), the drawing is completed in outline only, with no attempt at shading. Then, using black 'Indian ink' diluted with water to obtain the various tones required, washes are applied using watercolour brushes.

Above: Grey-headed Robin, *Heteromyias albispecularis*. A pencil and sepia ink tonal drawing using line and cross-hatching to indicate feathers and shadows.

Right: White-bellied Go-away Bird, *Corythaixoides leucogaster*. Studies like this, of live wild birds, record lots of information that is invaluable when working on the finished painting. It was done using B and 2B graphite pencils.

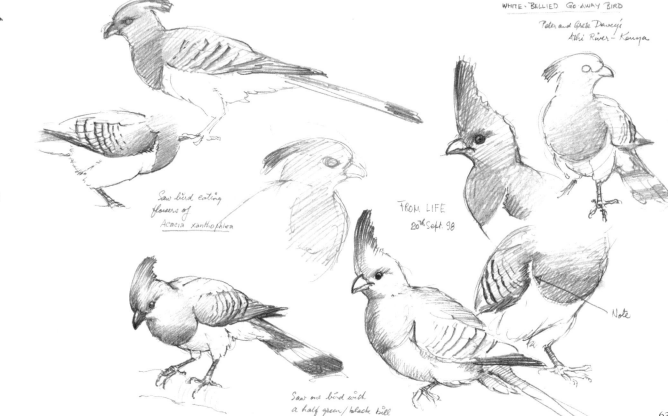

63

There is quite an array of instruments available for producing black and white work including lead pencils ranging from very hard (9H) through to very soft (9B). There are also charcoal pencils, carbon pencils, graphite pencils, graphite sticks, and so on. Paper stumps, also called **torchons**, are good for shading and blending charcoal or pencil work. A range of pens and nibs of all shapes and sizes can be found at most art dealers.

When starting a black and white drawing, it is important to keep the layout lines (the first attempts at getting the shape correct) very light. It is best if these are drawn with an HB or 2B pencil, using very little pressure so that the lines are easily removed if required. A hard pencil gives a nice light line but can leave dents in the surface of the paper and is harder to erase. Shading can be done using the side of the pencil or the point by using lines or cross-hatching. Highlights can be added by rubbing out or by leaving the white of the paper. I prefer a 'kneadable' rubber, although a harder white eraser is better for removing persistent lines. To keep the pencil sharp, I use a bench-mounted sharpener and follow up by gently honing the lead on very fine sandpaper mounted on a wooden block.

There are many types of papers and boards with many different surfaces for black and white work. Experimentation will tell you which surface best suits your requirements.

When drawing with a pen, shading can be applied by using fine line or cross-hatching. Ink can be diluted with water to varying tones and applied with a watercolour brush for smooth shading effects.

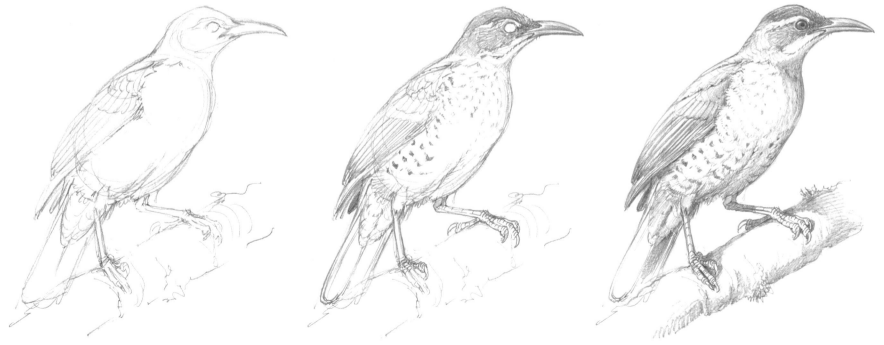

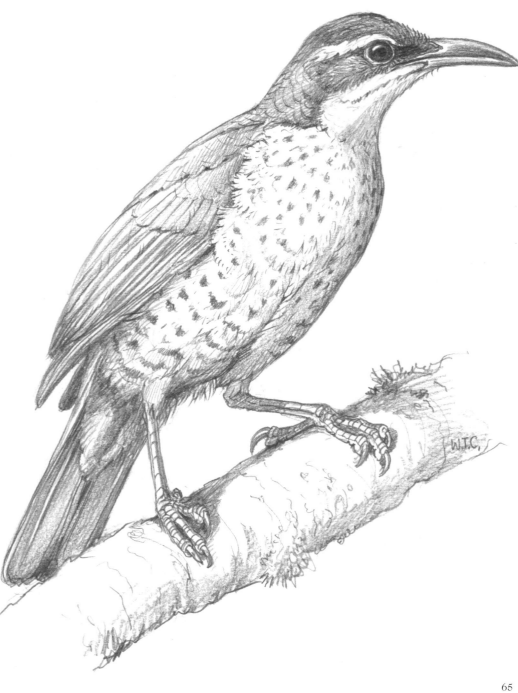

This spread: Victoria's Riflebird, *Ptiloris victoriae* (young male). Pencil drawing showing progression from head and body circles to finished drawing.

An attractive method of producing a tonal drawing (not strictly black and white) is to use a coloured paper with a tonal value of 5 or 6. Any soft grey, beige or green-grey works well. Draw and shade using black or sepia ink, or conté chalk and then add highlights in white **conté chalk** (see endpapers).

All work where pencil, charcoal or chalk has been used requires 'fixing'. Workable fixative is obtainable in spray cans and, once applied, prevents the work from smudging. As the name implies, it can be worked over again after it has dried.

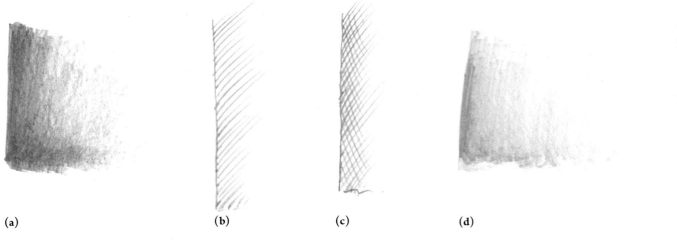

(a) **(b)** **(c)** **(d)**

(a): Shading with the flat side of a 2B pencil.

(b): Shading with lines using a 2B pencil.

(c): Shading with cross-hatching using a 2B pencil.

(d): Shading using an HB pencil and washed over with water on a Sable brush.

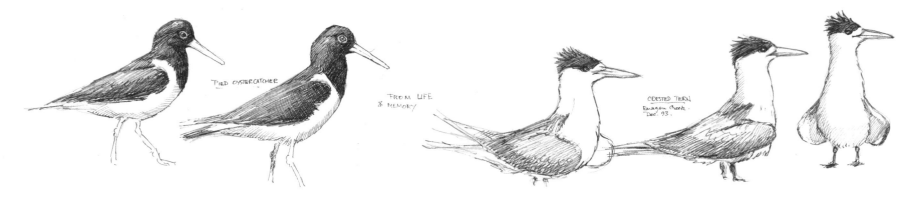

Ideas

Some of the best artists' works are outstanding as much for their ideas as for their skill. These ideas often do not come easily, especially new and different ones. It seems that whatever you dream up, somebody has already thought of it. I find that ideas often come from encounters with birds in the wild and I suggest that when you see some interesting behaviour (be it display, fighting, feeding, etc.), do a quick layout sketch – I mean *quick*, while the mental image remains clear. Make notes on these sketches or in the margin to emphasise your thoughts at the time. These little ideas may never become paintings, but it certainly is helpful if you can flick through a collection of thumbnail sketches when you are planning a painting.

Sometimes an idea for a picture may also come from the background. You may see a wonderful twisted branch with lichen or moss growing on it and it will trigger an idea to paint a particular bird hopping over it or searching and probing the moss for insects or grubs (see p. 69). Now this is when what I have been 'harping' on about comes into its own! *Your observations of living birds and your knowledge of bird structure are needed to put the bird on the branch.*

Unless you are doing identification paintings, where a bird can be static, I think it is good to have your bird doing something such as displaying, feeding or hunting. Even just a tilt of the head on a stationary bird, as if it has just seen an insect, gives an impression of something happening. Try to make your picture tell a story if you can.

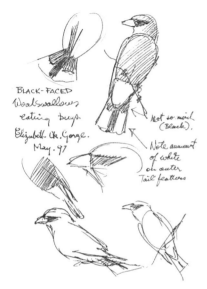

Above: Black-faced Woodswallows, *Artamus cinereus*. An example of a quick sketch.

Right: Spinifex Pigeon, *Geophaps plumifera*. A quick sketch to work out the composition for a proposed book illustration.

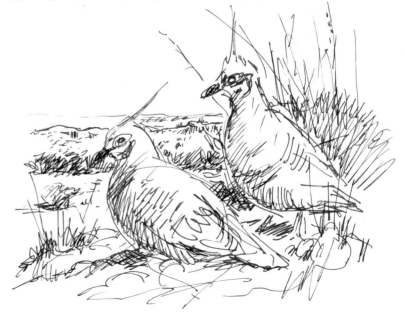

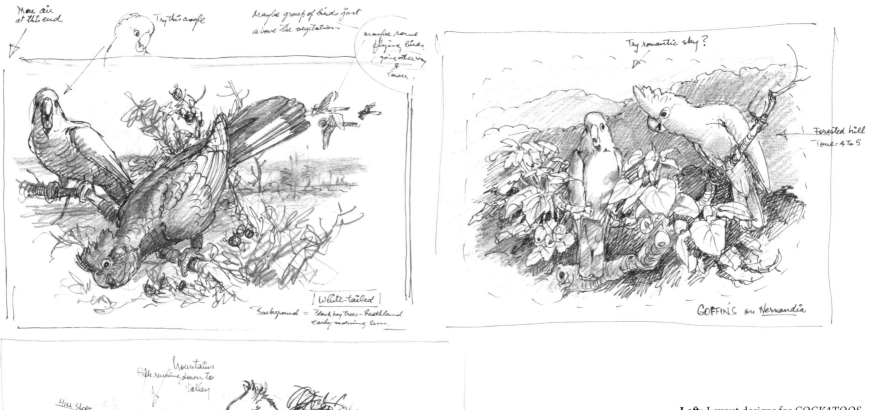

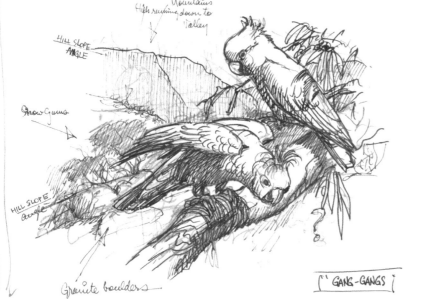

Left: Layout designs for *COCKATOOS – A Portfolio of All Species*. **(top left)** Carnaby's Black-Cockatoo, *Calyptorhynchus latirostris*, **(above)** Goffins Cockatoo, *Cacatua goffini*, **(left)** Gang-gang Cockatoo, *Callocephalon fimbriatum*. These are three of the first design sketches for a publication, which covered 21 plates. It was important that the composition was different for each species. When illustrating a number of species, sketches like these help avoid similarities between plates.

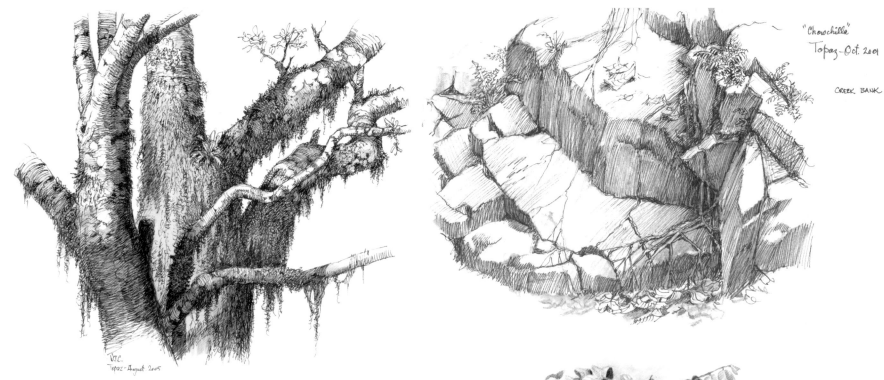

"Chowchilla"
Topaz - Oct. 2001

CREEK BANK

Above: Mossy limbs. I have never used this particular subject in a painting, but when I saw it, I couldn't resist getting a detailed drawing to put in a file. It is very useful to have lots of drawings like this when you are planning a painting.

Right: (top) Creek bank. Another reference drawing that was used in a painting.

Right: Sapling. I thought this young tree could be useful in a future background.

Backgrounds and extras

When composing a painting, it is very helpful if you have a collection of drawings of background ideas to which you can refer (see below).

Seeing birds feeding on particular flowers or fruits allows you to draw and paint them for future reference (see pp. 71 and 72). Prey animals could be insects, mammals and other birds, or they may be reptiles, fish, crabs, centipedes or snails – anything a bird might eat (see p. 73). If you should catch a mouse in the house then make use of it. Draw it from many angles and positions, imagining it is under the foot of a bird of prey.

Always make notes of the location and date on your reference drawings so that you don't put a southern bird with northern prey. Make careful note of the size of your subject so that you can keep the relationship between prey and bird correct. This sort of attention to detail is what gives your painting authenticity.

Below: Watercolour test sketches for backgrounds. Testing to be sure of which colours will be used.
Note: Rose Madder Genuine should not be used on a finished painting as it will fade or change. As a substitute, use Permanent Rose.

Right: Botanical drawings. A few examples of botanical reference drawings done after watching birds feeding on the plants. **(far right)** *Cissus* sp. **(right)** Nutmeg, *Myristica* sp.

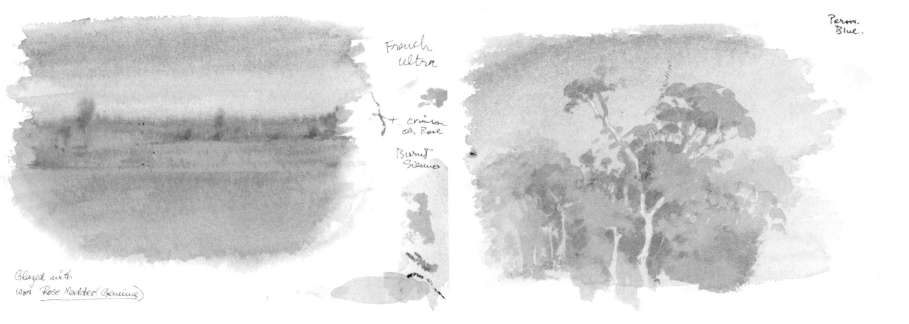

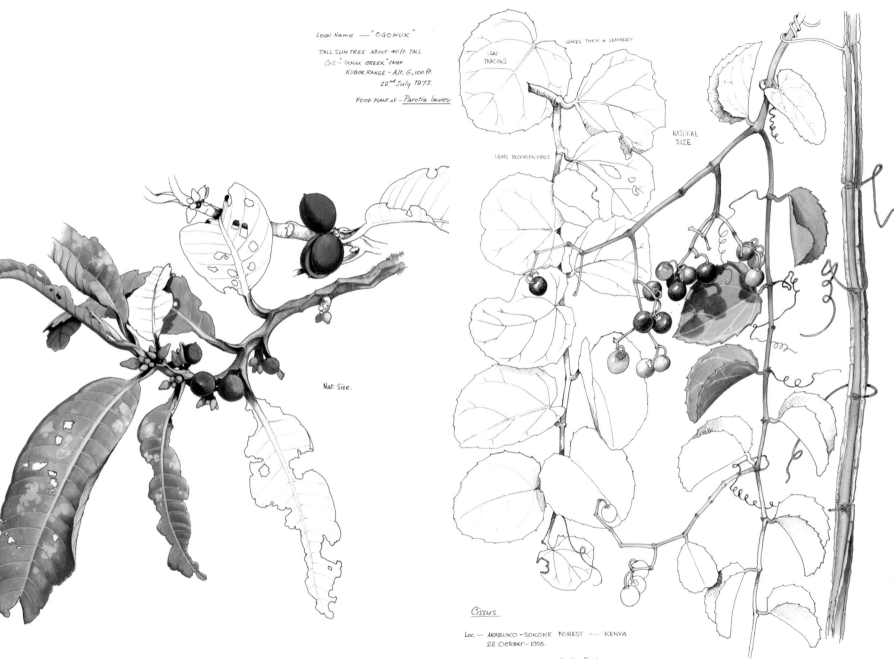

Local Name — "OGOMUK"

TALL SLIM TREE ABOUT 40 ft. TALL
Coll.— "TAMAK CREEK" CAMP
KUBOR RANGE — Alt. 6,100 ft.
22nd July 1973.

FOOD PLANT of — *Parotia lawesi*

Nat: Size.

LEAF
TRACING

LEAVES THICK & LEATHERY

VEINS INCONSPICUOUS

NATURAL
SIZE

Cissus

Loc.— ARABUKO-SOKOKE FOREST — KENYA
22 October-1995.

FISCHERS TURACO — eats the fruits

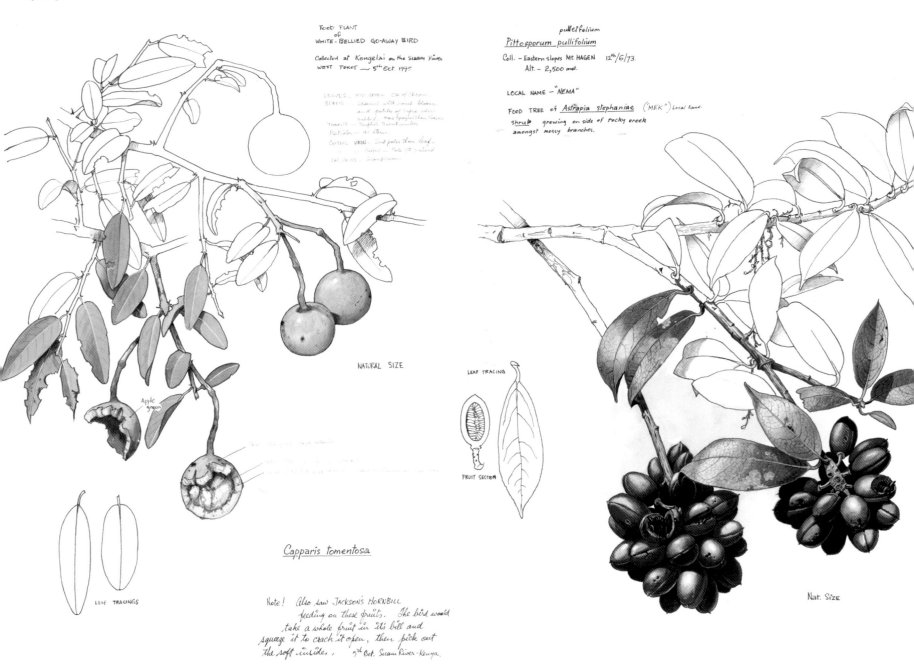

FOOD PLANT
of
WHITE-BELLIED GO-AWAY BIRD

Collected at Kongelai on the Suam River
WEST POKOT — 5th Oct. 1975

LEAVES — MID GREEN OK of Sterns.
STEMS — chestnut with round blooms
and patches of sepia when
rubbed. more grey/olive than leaves
THORNS — Purplish/brown/amber
Petioles — as stem.
CENTRAL VEINS — 2nd paler than leaf,
Recessed — Pale & raised
LAT. VEINS — Inconspicuous.

NATURAL SIZE

Apple
green

Capparis tomentosa

LEAF TRACINGS

Note! Also saw JACKSON'S HORNBILL
feeding on these fruits. The bird would
take a whole fruit in its bill and
squeeze it to crack it open, then pick out
the soft insides. 5th Oct. Suam River-Kenya.

pulleifolium
Pittosporum pullifolium

Coll. — Eastern slopes Mt. HAGEN 12th/6/73.
Alt. — 2,500 met.

LOCAL NAME — "NEMA"

FOOD TREE of *Astrapia stephaniae* ("MEK") Local Name.
shrub growing on side of rocky creek
amongst mossy branches.

LEAF TRACING

FRUIT SECTION

Nat. Size

HOUSE MOUSE
(for prey) May 97.

W.T.Cooper Nov.1977.

Dead Honeyeater

"CHOWCHILLA"
TOPAZ
28/12/88

Left: Botanical drawings. **(left)** *Pittosporum* sp. and **(far left)** *Capparis* sp. These have all been used in published paintings.

Right: It is also helpful to have many reference drawings of possible prey animals. Take advantage of any such creatures you may find **(right)** house mouse **(far right)** katydid **(above)** skink **(top right)** dead honeyeater.

PLUMED TREE·DUCK

Hattas Swamp.
FROM LIFE
2003

Part B – the paintings

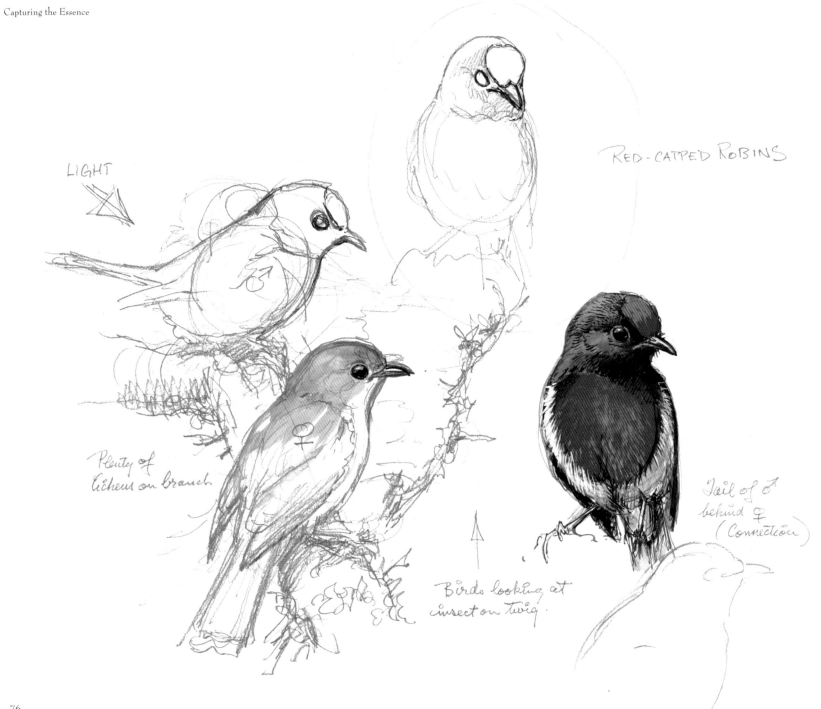

LIGHT

RED-CAPPED ROBINS

Plenty of
lichens on branch

Birds looking at
insect on twig.

Tail of ♂
behind ♀
(Connection)

A painting in watercolours

From when you start a painting you must put your very best into it and yet be willing to trash it
if it doesn't come up to scratch. – DAVID LEFFEL

For this painting of Red-capped Robins, *Petroica goodenovii*, I am using a sheet of Fabriano Artistico 640 gsm CP (cold pressed surface). This is a heavy paper, which for a smaller painting does not require stretching. The choice of brushes is a very personal thing and with experience you will find which suits you best. A wad of clean absorbent rag for wiping brushes should always be at your side. Water containers need to be wide-mouthed and very stable. Always keep one container clean and wash brushes in the other. The clean water is there in case of an accident where a brush may flick a spot of paint, or a brush may even be dropped onto your work. If this should happen, grab a clean tissue and dab the spot carefully – do not rub. Then with an old brush that has been especially cut for the job to act as a scrubbing brush, together with the clean water, see if the spot will gently wash off. Some colours are staining and cannot be removed (check a colour chart for this information). Always have a clean piece of paper beneath your hand when you are working so that the grease from your hand does not penetrate the watercolour paper. For this purpose, an artist friend suggested a cotton glove with the painting fingers cut off.

Materials

Watercolour paper

Fabriano Artistico 640 gsm CP (cold pressed surface). This paper has a medium texture, which is good for washes but still enables fine detail. A piece 38 × 45 cm was used, which allows for plenty of space around the actual painting.

Tracing paper

Calque Satin Canson 110/115 gsm

Paints

Any artist's quality tube watercolours. For this painting I am using Winsor & Newton Artists' Watercolours.

Scarlet Lake	Burnt Sienna
Winsor Red	Sepia
Winsor Red Deep	Ivory Black
Winsor Orange (Red Shade)	Neutral Tint
Winsor Blue (Green Shade)	Winsor Violet

Winsor & Newton Designers Gouache – Permanent White

Containers

2 wide-mouthed water containers

Brushes

No. 3 Proarte Series 1 Kolinsky Sable	No. 0. Neef 990 Taklon Script
No. 4 Proarte Series 1 Kolinsky Sable	No. 2. Neef 990 Taklon Script
No. 6 Proarte Series 1 Kolinsky Sable	

Extras

Palettes – heavy ceramic palettes are preferable because accidents are more likely to happen with the light plastic variety.
Absorbent cotton rags
Magic Removable Tape

The process

Previous spread: Red-capped Robins, *Petroica goodenovii*, are an attractive subject and ideal to demonstrate a small watercolour painting. The first sketches and ideas were roughed out until a vision for the finished painting was arrived at. The male with his head turned was decided upon for the final composition.

Left: The birds have been drawn in their position on the branch, and can now be transferred to the watercolour paper. If they were drawn onto tracing paper and then the paper turned over and transferred, the image would be the reverse of the original. I wanted the picture to be facing the same way as the original and so it had to be traced twice. It was first traced from the original onto a piece of tracing paper using a fine felt-tipped pen. The tracing was then turned over and drawn with a B pencil, carefully following the ink lines showing through the tracing paper. The tracing was then turned over again so that the pencil tracing was face down on the watercolour paper. It was attached in position using Magic Removable Tape, and was then rubbed firmly over the ink drawn side with a carpenter's pencil (hard), which transferred the pencil tracing onto the watercolour paper. The reason for using a carpenter's pencil is that its broad chisel-shaped lead avoids making grooves in the paper like a fine sharp pencil can. Also it does not leave dust, which can creep onto your clean paper.

Right: The picture is more or less split into quarters by the design, which makes laying the background washes easier. It is difficult to wash completely around a subject without getting a hard edge somewhere. The colour for the wash was mixed using Winsor Blue (Green Shade) and Burnt Sienna. Each area to be washed was wetted using a No. 6 Sable brush, being careful not to let the water onto any part of the foreground subject. If the part of the robin to be white was allowed to get wet, the background colour, when washed on would travel onto it and present problems later.

The wash was laid down using a No. 4 Sable brush. When washing in a section, turn the paper so that the outside of the wash (the part that fades away) is to the top of your sloped board. This way the faded area will not get a hard edge. The wash will sink down until it meets the dry edge of the subject. Once the four quarters of the background had their first wash, some suggestion of trees was worked in, using the same background wash colour.

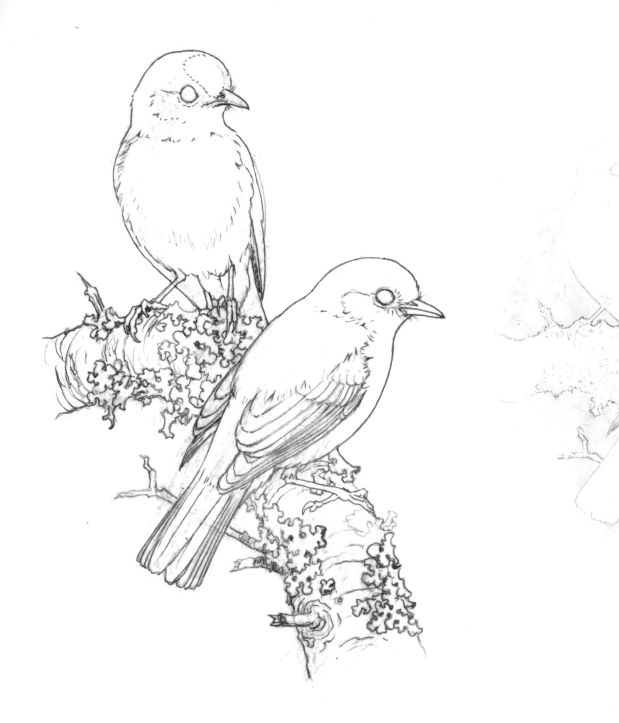

Right: More work on the background was done by using the original background wash with a touch of Winsor Violet added. With this darker wash, more definition of trees and leaves was added, but without too much detail.

Lichens and the branch were worked up using a very pale wash of Winsor Blue (Green Shade) for the lichens and a pale wash of Sepia for the branch. Some Winsor Violet was added to the Sepia for shadows. Detail of the lichens and branch were developed to a point where it was evident that the tonal values of the background and lichen-covered branch were going to work.

The shadow of the female was cast onto the branch using Sepia mixed with Winsor Violet. This shadow also runs over some of the lichen. The detail within this shadow now gives the effect of light within shade.

Right: (middle) Colour was added to the lichens using a very weak wash of Winsor Blue (Green Shade) with a touch of Permanent White Gouache to make the colour less intense and more milky. This detail work on the branches and lichen was done using No. 3 Sable and No. 2 Taklon Script brushes.

The first patches of red were painted onto the male bird using Windsor Orange (Red Shade) and Scarlet Lake. The red was placed before the black, because if the black had been put down first and allowed to dry, when the red was painted right up against it, the black may have bled into the red and could never have been corrected. On the other hand, when the red was down and dried, and black painted up against it, there would have been no problem if the red bled into the black. It could easily have been covered by more black.

Shadows were developed on the red areas using first Winsor Red then Winsor Red Deep. The colour red is a very difficult colour for printing. It tends to become one red all over unless the light and shade are well emphasised. If your work is to be reproduced, the darks and lights on your reds need to be exaggerated.

The eyes were placed in the birds' heads but not completed – detail would be added later.

Far right: Using various tones of a wash mixed from Winsor Blue (Green Shade) and Burnt Sienna, shadows were started on the white areas of the male bird. The black areas were added using a strong wash of Neutral Tint and the shaded areas are Ivory Black. Feather detail on the light side of the black area was achieved by using a mix of Neutral Tint, Ivory Black with the Permanent White Gouache added, on a No. 0 or No. 2 Taklon Script brush.

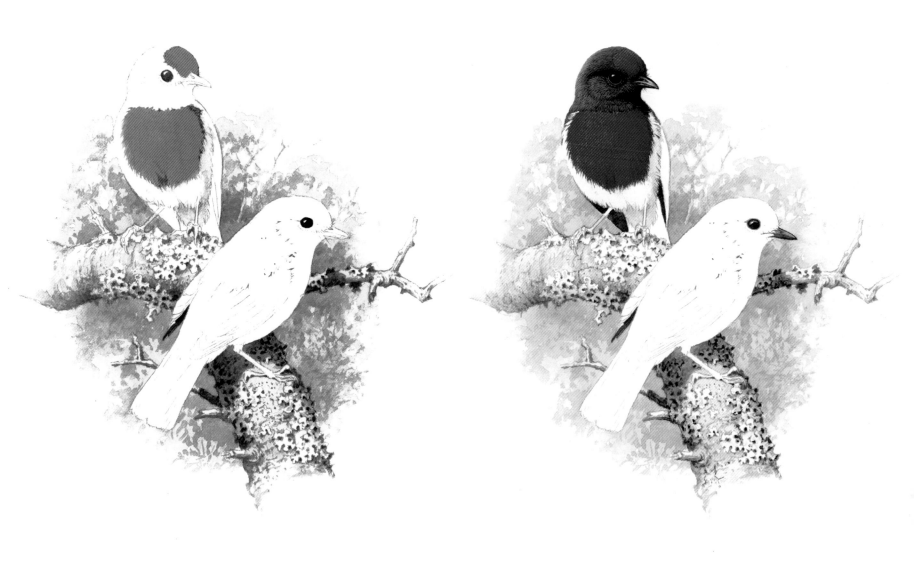

Right: Shaded areas on the red breast and cap of the male were painted with Winsor Red Deep. A weak wash of Scarlet Lake was used on the forehead of the female and a soft grey-brown wash was applied on the back using Sepia and Neutral Tint. Once the wash was dry, the area was worked over using the same mix to do the feather detail using a No. 0 Taklon Script brush.

The male was now as good as completed, having had the legs and feet detailed as well as the wing and under tail area.

Right: (middle) The soft greys and browns of the female are not specific enough to describe in detail. They are mixes of Sepia, Burnt Sienna and Ivory Black and were used very sparingly until a base colour was arrived at. I suggest plenty of experimentation on separate paper until you get the colour you need.

To do the detailed feather work, the same colours were used, but not as thinly, with a No. 2 or a No. 0 Taklon Script brush. The darker strokes were laid down first and then using the same colours, but with Permanent White Gouache added, pale strokes were laid over the top.

Shadow on the throat and breast of the female was applied using the same wash as the white area on the male but with a touch more of the Burnt Sienna.

Far right: Other than the red against black, the sequence of development is not so important because how the picture is working often dictates which area is painted next.

A darker brown-grey was mixed for the wings and tail of the female. Take particular care to leave the white of the paper where there are white edges to feathers of the wing. Inevitably a little wobble can occur when applying the dark brown, but it can be corrected by coming back over the white edges with Permanent White Gouache, to which the tiniest amount of Cadmium Yellow Deep has been added.

The whole picture was studied carefully for areas that could be improved upon by a little more shadow or where the tonal values needed to be adjusted. A small flying insect was placed on the branch on the right-hand side of the picture. This added 'story' to the painting, giving the birds a reason to be looking in that direction.

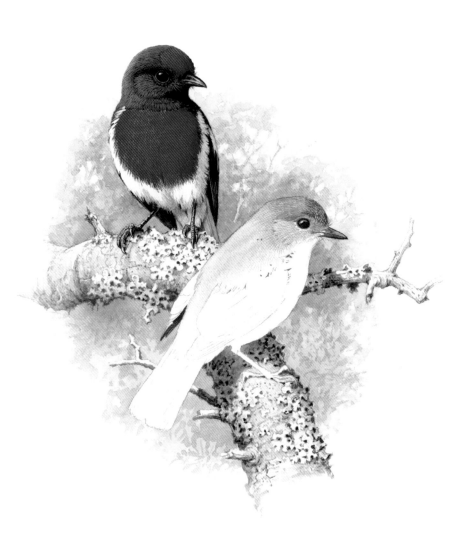

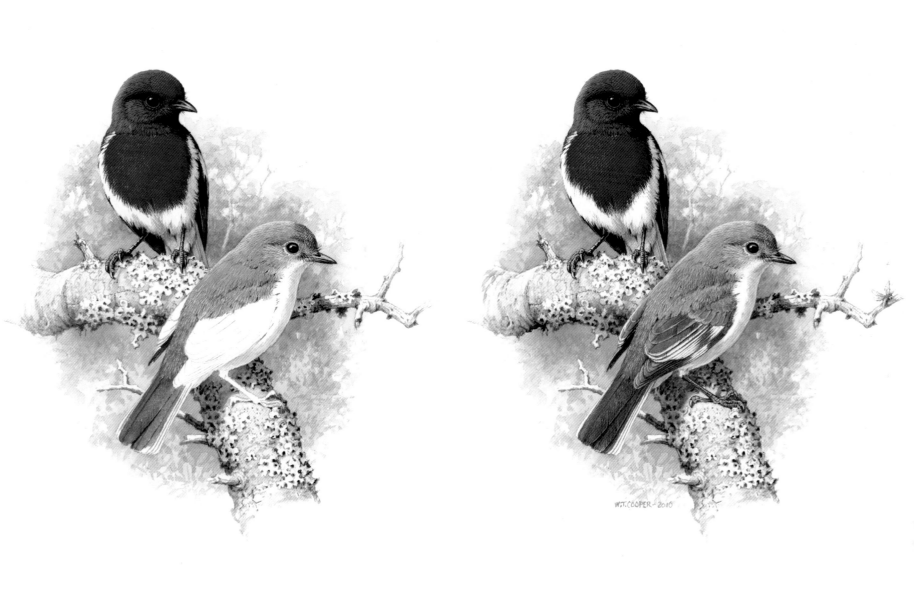

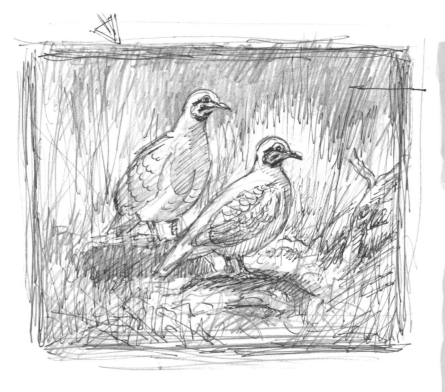

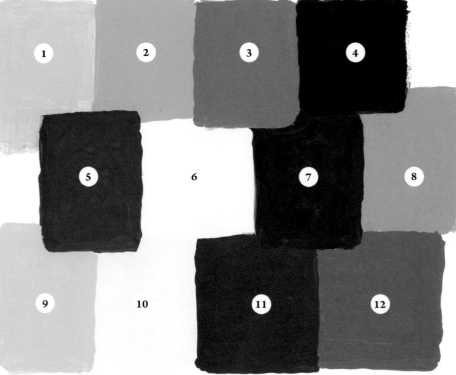

Burnt Umber Toning Grey – Yellowish
Raw Umber " " – Pinkish
Naples Yellow " " Mid
Jaune Brillant Warm Grey
Titanium White Mars black
Burnt Sienna

A painting in acrylics

The demands of painting will always remain greater than your expertise. – RICHARD SCHMID

For this demonstration, I have chosen Squatter Pigeons, *Geophaps scripta*, which are soft almost monochromatic birds. Sketches were done from wild and captive birds and checked against photographs for positions of markings, and a compositional layout was planned and chosen.

Left: A layout sketch for the proposed painting.

Right: A prepared colour chart shows colours as they will appear when dry.

Colours were mixed and checked after drying. Because acrylics dry darker than they are when first applied, it is best to mix all the main colours of your picture before starting. Ten different colours were mixed for this painting. For instance, colour No. 3 was mixed using Naples Yellow, Raw Umber, and Toning Grey Yellowish. These colours were blended in a container and a quantity of Liquefying Medium (usually a bit less than half the quantity of paint) was added and then a small amount of water until the required consistency was reached. The correct consistency can only be arrived at by trial and error – until it flows freely from your brush. Paint a colour patch on the lid and give it a number. Also make a small colour chart with corresponding numbers.

It is important when using acrylics to keep your brushes wet, and to wipe out excess water on a rag before dipping into paint. This helps to prevent the paint, which is fast drying, from clogging up the base of your brushes. Keep washing your brushes as you work and always drop them into water when you have stopped working.

Materials

Paints

Atelier Acrylics (Interactive Artist's Acrylics)

Burnt Umber

Raw Umber

Burnt Sienna

Cobalt Blue

Cadmium Red Medium

Naples Yellow

Jaune Brilliant

Warm Grey

Mars Black

Toning Grey Mid

Toning Grey Yellowish

Toning Grey Pinkish

Titanium White

Mediums

Atelier Liquefying Medium

Atelier Clear Painting Medium

Clean water

Containers

Plastic take-away food containers 50 mm deep, with lids, 75 mm diameter
(or any size near that)

These containers can be purchased quite cheaply from packaging outlets in
packs of 100

Two or three water containers

Brushes

No. 2. Neef 990 Taklon Script (Rigger or Liner)

⅛ Neef 980 Taklon (Long flat)

¼ Neef 980 Taklon (Long flat)

⅝ Neef 980 Taklon (Long flat)

Extras

Plastic palettes

White conté chalk

White carbon paper (available from craft supply shops)

Tracing paper

Paddle-pop sticks for mixing paint (available from art or craft supply shops)

2H or 4H pencil for transferring on tracing paper

Absorbent rags – old cotton sheeting is best

The process

Right: For this painting I prepared a piece of 5 mm craft board by double
coating the back and edges with polyurethane. The front was sanded and
given two coats of acrylic gesso applied with a small foam roller then
sanded lightly and given a third coat of gesso. The surface was again sanded
very lightly to attain a fine 'orange-peel' surface.

Once the board was prepared I covered the entire picture area with the
main middle-tone (No. 3) and then while still wet, the darker colours (No.
4 and No. 5) were broadly and quickly brushed from the top down into
the middle tone (No. 3), and the middle tone brushed back into the darker
top area. Once the rough background was dry, the birds were drawn to
the size required, then positioned and traced on using white carbon paper.
The branches were drawn in with white conté chalk. Based on the birds
in the rough layout sketch, more careful drawings were done on tracing
paper, and these were transferred onto the board which already had the
background colours loosely painted in.

To transfer the drawings, they were simply attached to the board
in the required position with Magic Removable Tape, and because the
background colour was dark, a piece of white carbon paper slipped in
behind them. Then using a 2H or 4H pencil, the outlines of the birds were
carefully followed, using pressure on the pencil to be sure the carbon paper
fully transferred the image.

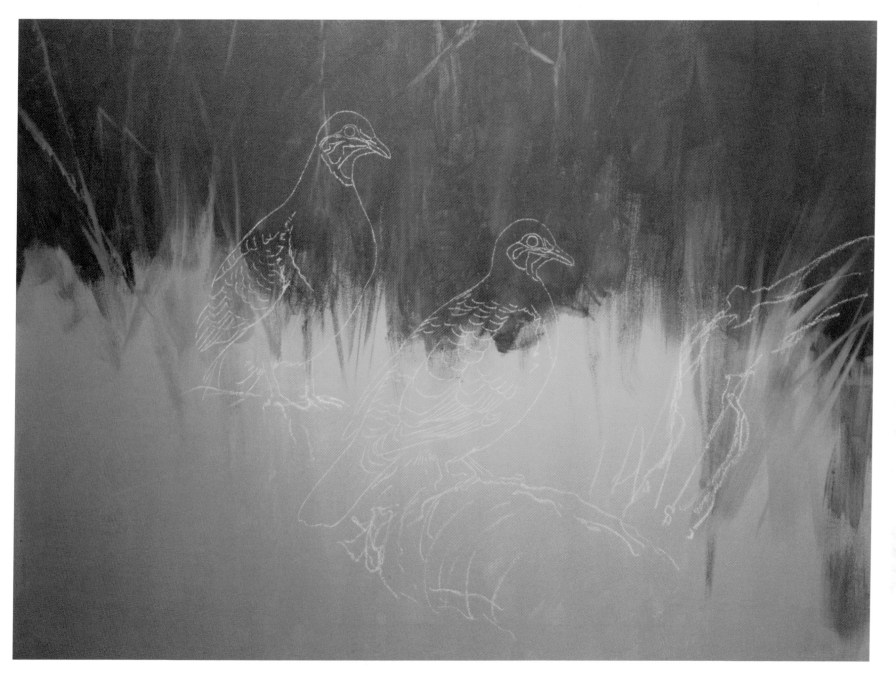

Right: Suggestions of a leafy bush were painted into the top right-hand corner. Then using mix No. 3 some grass stems were worked in behind the figures of the birds.

Following spread: (left) Next, the dead eucalyptus branch on which the birds are perched, was started by using the darker shade colour (No. 5). Light was then added using No. 8 (a mix of Toning Grey Yellowish and White). To blend the light with the shadowed side, Clear Painting Medium was painted onto the branch and then light was added using white with a little of mix No. 6 added, and quickly blended before the medium had dried. A small amount of Toning Grey Pinkish was added directly to the lights and darks of the branches.

Following spread: (right) By working over a wet dark area with the dry grass colour (No. 3), the dark and light colours blend, giving lots of tones in between the two. More grass stems were added and at the same time more detail was added to the branches. Some detail on the birds was begun, while overall tonal values were assessed.

Two more colours were mixed for the birds (No. 11 and No. 12), and No. 8 of the originally mixed colours was also used for the birds. These three colours were basically all that was needed for the brown tones of the birds. More work was done on the birds.

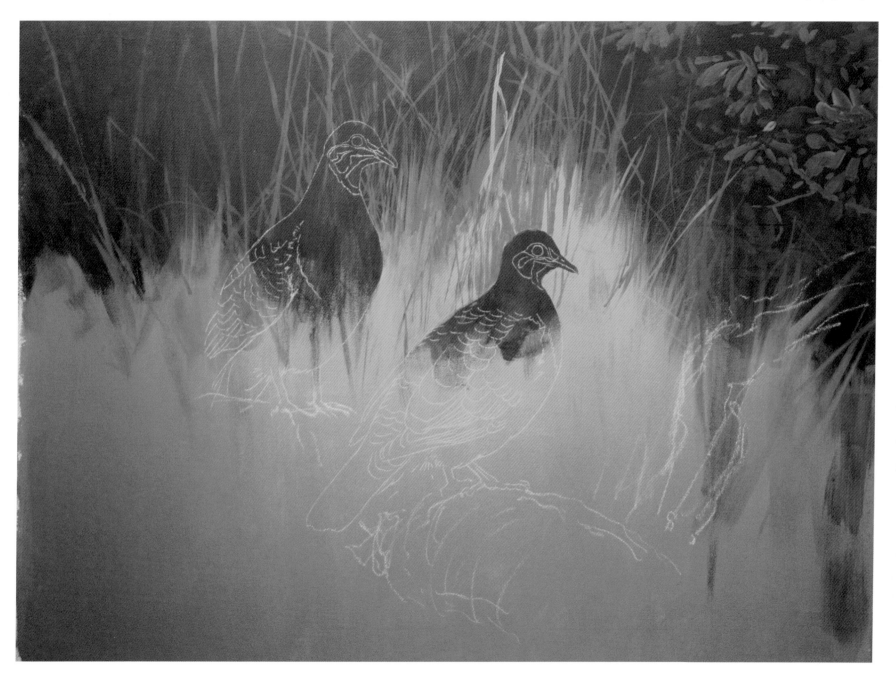

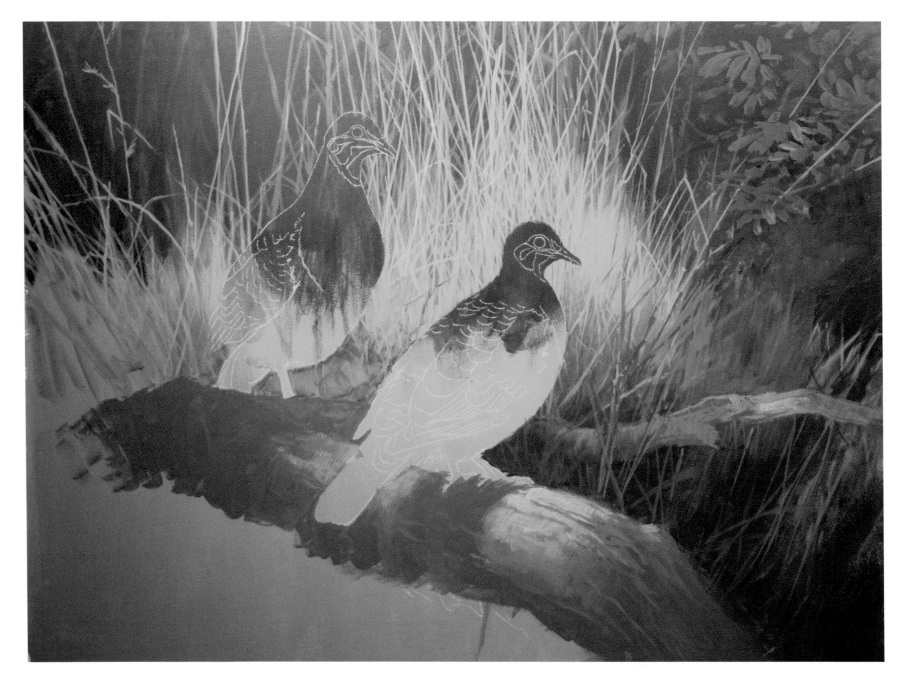

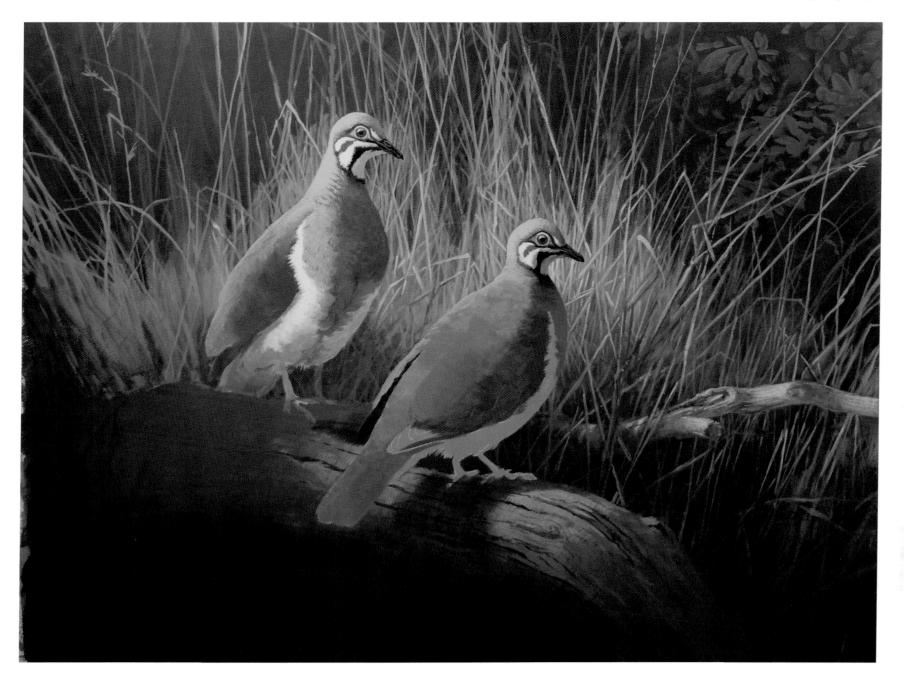

Right: Refinement of detail and tonal values were worked on here. Work was done on the birds and on the grass behind the birds at the same time in order to achieve the tonal balance needed to lift the birds from the background.

Following spread: (left) The pale ends to the wing feathers were now painted but not refined. At this stage it seemed more thought was needed to get the balance of tones working, and so bits and pieces of detail were added all over the picture and small corrections made. This is when you are glad that you have the base colours ready mixed so you can touch up here and there with the confidence that the colour will dry to what you want it to be.

Now a lot of important detail was being added, jumping all over the painting to ensure everything is balancing. Finer feather work was achieved using the No. 2 Taklon Script brush. More light was added to the birds and more darks into the grass behind them.

Following spread: (right) More grass detail was done and some added to the right-hand foreground. A few grass stems from the immediate foreground travelling across the dark in front of the bird on the right, added depth and perspective to the picture.

The iridescent feathers in the wings were added. The areas to take the dark green and purple were painted first with white and then green and purple worked thinly over the top as glazes. A **glaze** is achieved by thinning the paint with Atelier Clear Painting Medium. This gives more brilliance or glow to the colours, as the white underneath shines through.

Branch details were refined and grass stems painted in below the branch on the lower left. Details of feet were added to the birds.

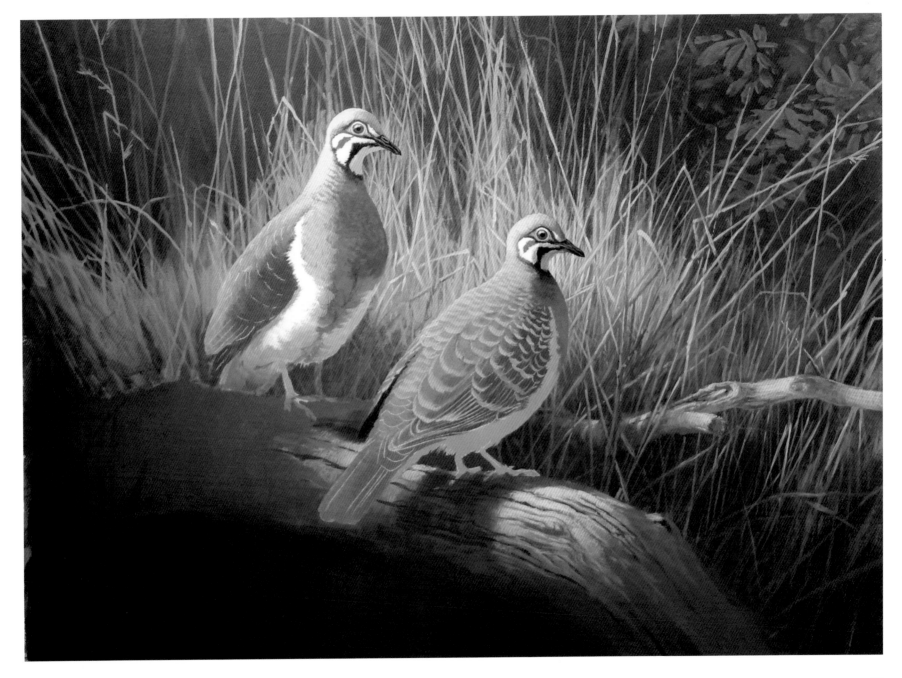

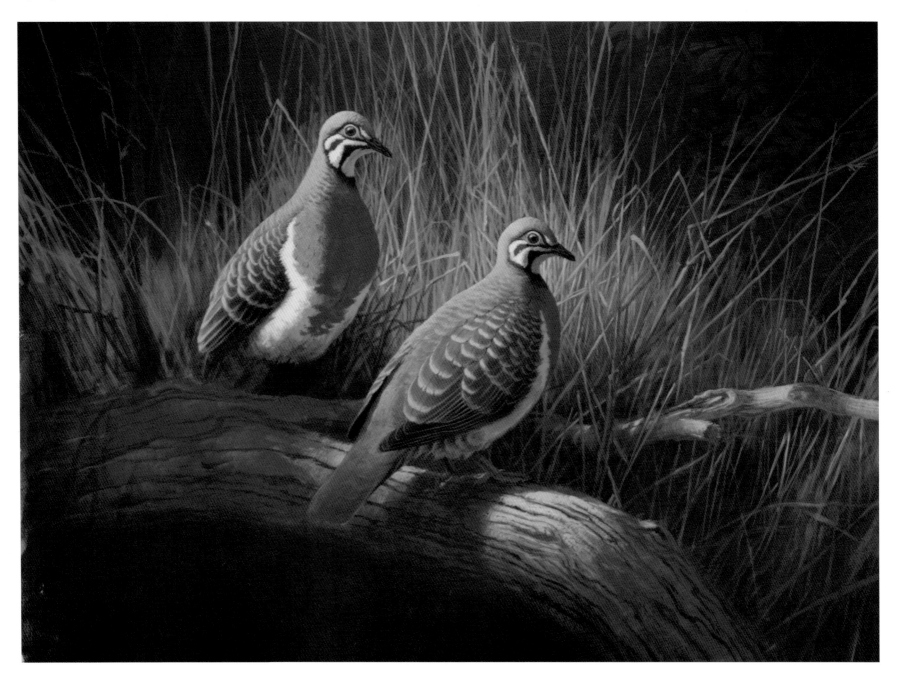

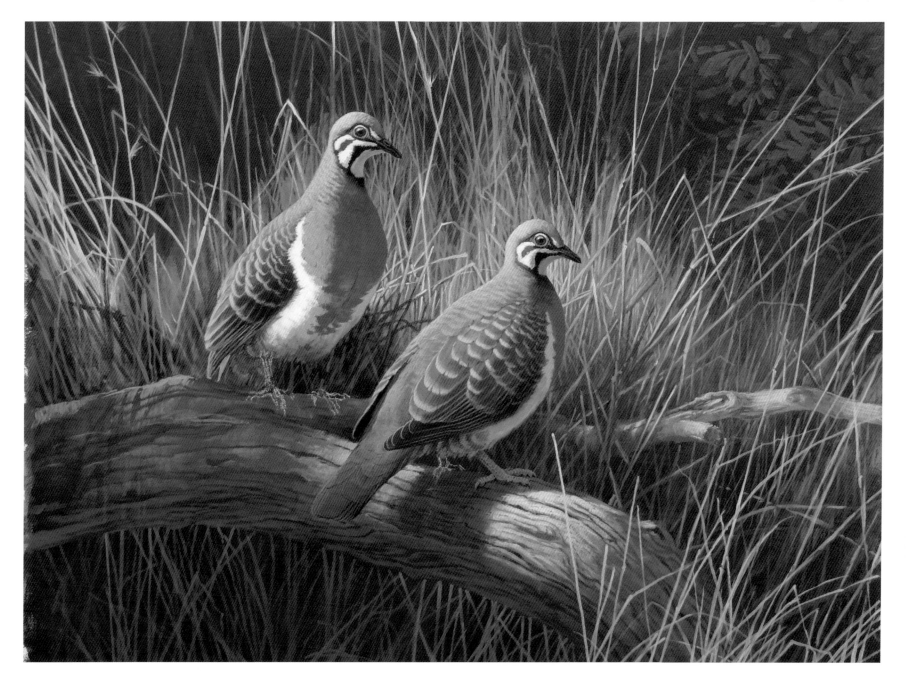

Right: I was not happy with the grass on the left below the branch, so changed this by working in a few stones and some rubble and the base of a tuft of grass. That allowed me to achieve more depth by bringing its long stems up in front of the bird on the left. Shadows of grass stems were shown travelling over the branch where more light had been added to allow this effect. The tip of the tail on the right-hand bird was given more light to lift it away from the branch.

The painting was checked by looking at its reflection in a mirror. This gives a fresh look at the painting and often shows up things that can be improved. A little touch of light here and there and the painting was finished. Varnishing acrylic paintings is optional; however, I like to varnish because it gives an even all-over sheen and brings any sunken dull patches of colour to life.

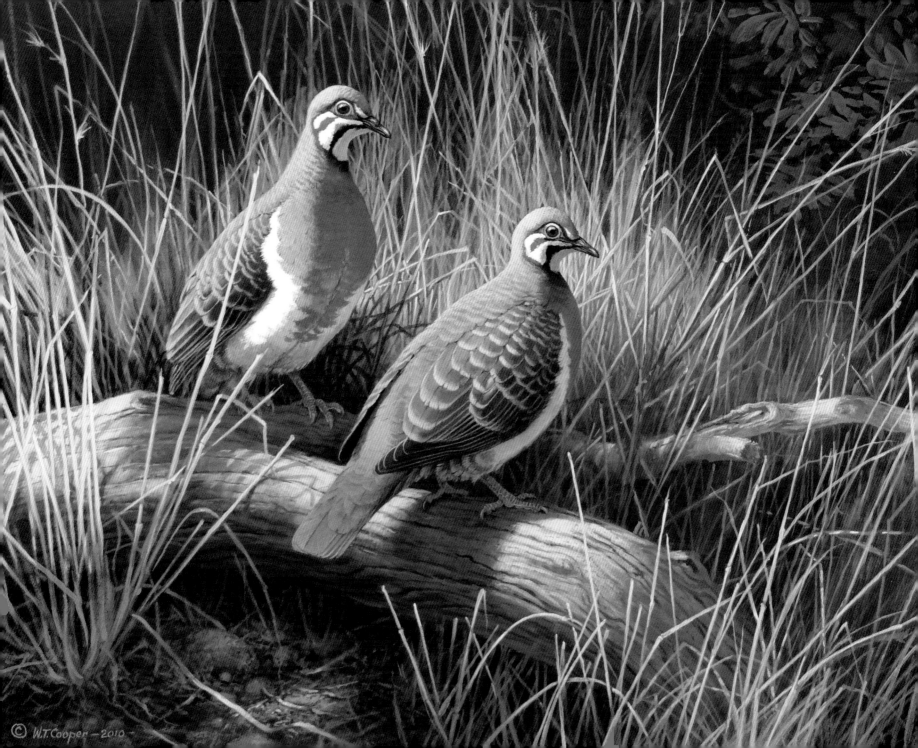

© W.T. Cooper — 2010 —

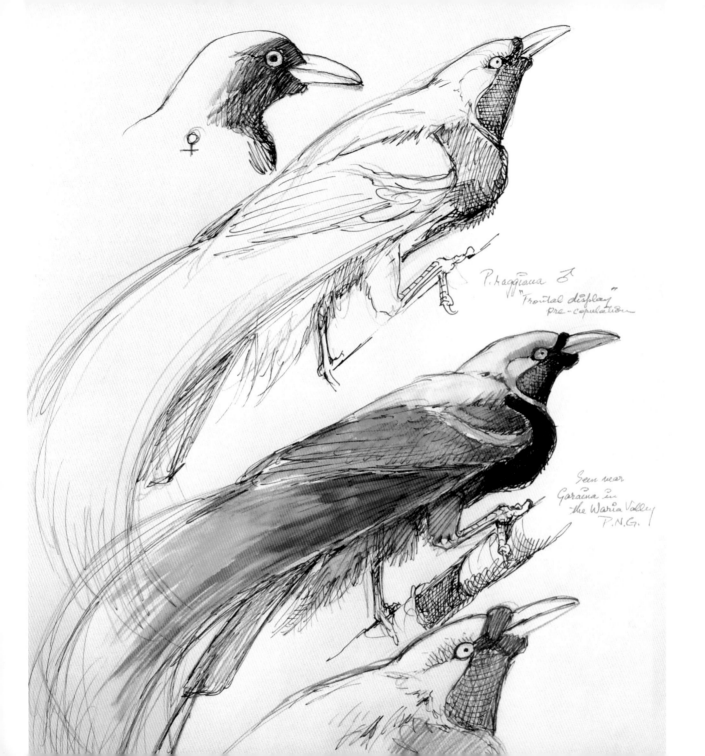

P. raggiana ♂
"Frontal display"
pre-copulation

Seen near
Garaina in
the Waria Valley
P.N.G.

A painting in oils

No one can call himself an artist unless he can carry a picture in his head before he paints it. – MONET

The subject chosen for this painting is Raggiana Birds of Paradise, *Paradisaea raggiana*. They are spectacular birds that live in the jungles of New Guinea. A canvas measuring 125 × 90 cm was glued to high-density craft board by a professional framer. It was then given two coats of white gesso and sanded between coats.

Painting in this medium does not have to be messy, which is the complaint most often made about oils. Setting the work-table out strategically so that you are not reaching over wet palettes to wash brushes avoids accidents. Wipe the top of the paint tube and put the cap back on after squeezing out colour to help prevent mess. Clean brushes immediately after use. Use disposable palettes and don't let paint tubes accumulate on the work surface. Keep lids on your white spirit jars so that you are not breathing any fumes and always work in a ventilated area. Common sense organisation can keep mess to a minimum, and it is certainly possible to finish a day's work without any paint on your hands.

Materials

Paints

I have used *Art Spectrum* oils for this painting only because I have become accustomed to the colour range and getting the right mix is easier when you know the colours well.

White acrylic gesso (although this is an acrylic gesso it can still be used for oils)

Raw Umber	Light Red
Greenish Umber	Cadmium Red
Burnt Sienna	Australian Grey
Pthalo Blue	Titanium White
Ultramarine	Transparent Black
Naples Yellow	Australian Leaf Green (dark)
Cadmium Yellow Pale	Sap Green
Jaune Brilliant	

Mediums

white spirit (to save using large quantities of white spirit, wipe and squeeze paint out of brushes with toilet paper before washing in spirit)
Art Spectrum No. 1 Medium
Winsor & Newton Liquin (original)

Containers

2 wide-mouth glass jars with easily removable lids

Brushes

2″ house painting brush (for gesso)
No. 6 Hog Bristle Fan (Blender)
No. 2. Neef 990 Taklon Script (Rigger or Liner)
⅛ Neef 980 Taklon (Long flat)
¼ Neef 980 Taklon (Long flat)
⅝ Neef 980 Taklon (Long flat)
¾ Neef 980 Taklon (Long flat)
⅜ Neef 980 Taklon (Long flat)

Extras

Rags
Palette knife
Disposable paper palettes
Roll of toilet paper
Mahlstick

The process

Previous spread and left: Field sketches were perused and postures chosen that showed two males in different positions of display.

Following spread: Two small (approximately 28 × 38 cm) oil sketches were done, the first of which I abandoned in favour of the second composition, which shows two males in display and a female watching on. This was used as my reference sketch. When males display, they bounce about in the upper branches of the forest, calling loudly and throwing out their plumes to attract the females. The aim of the painting was to capture some of this excitement, as well as show the habitat in which these wonderful birds live.

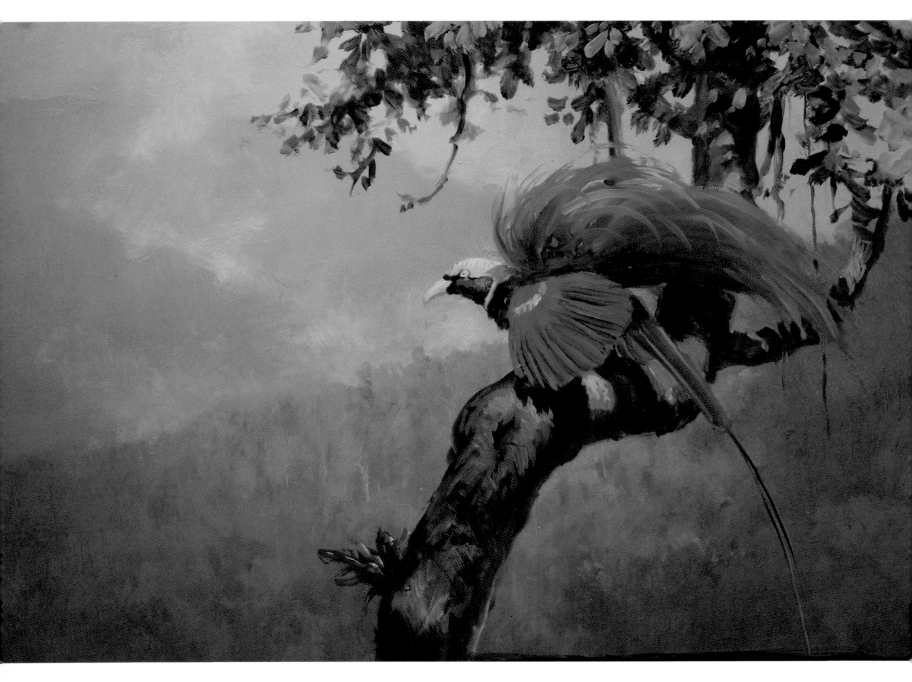

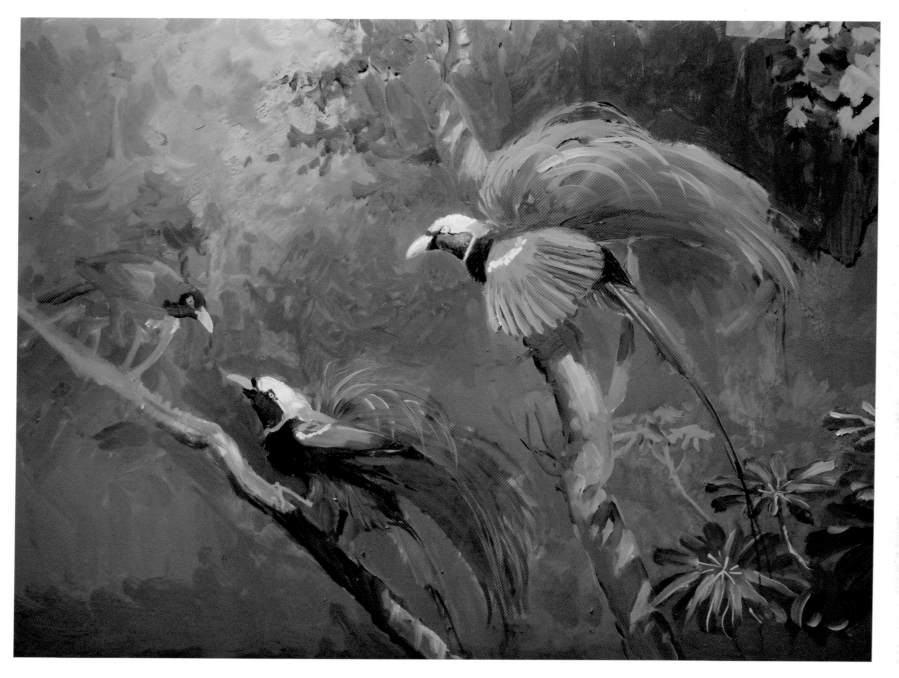

Right: The background was loosely painted and the branches and birds positioned, working to the layout of the small oil sketch.

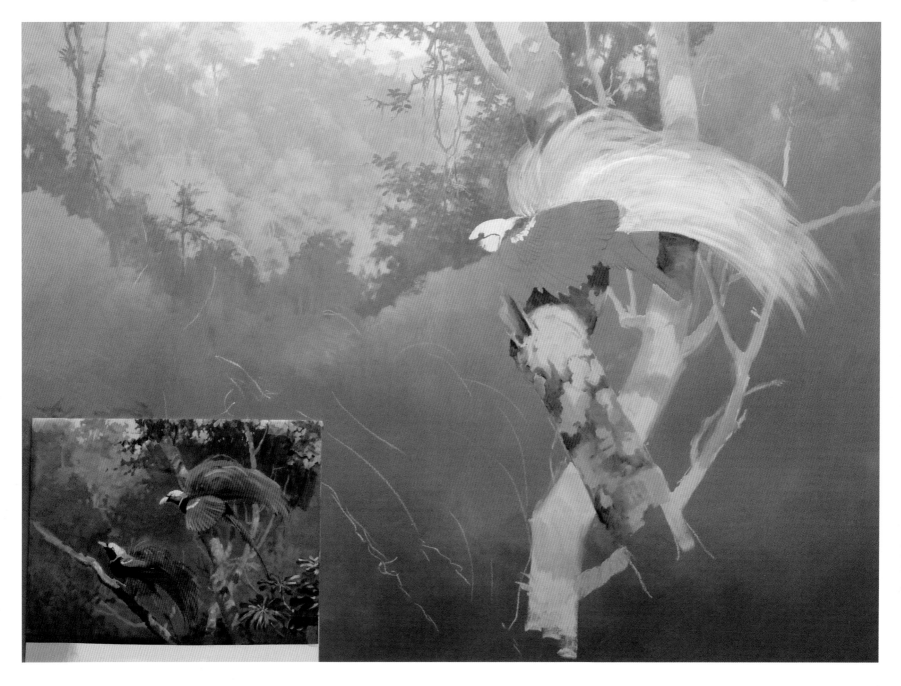

Right: The plumes and heads of the two males were painted white. This acts as an undercoat for the bright pinks and yellows and helps to retain the brilliance of the colours. Even though the picture was following the layout of the preliminary oil sketch, I found that I was not happy with it. On the larger scale, it was becoming too heavy and there was not enough air in the upper part of the painting.

Following spread: (left) A new idea for the background was started with mists rising out of distant valleys using a No. 6 Hog Bristle Fan brush. The original idea of the main branch and the two male birds was retained. Some detail was applied to the main branch with a ⅛ and a ¼ Taklon brush, a small clump of moss at the base of the dead protrusion and lichen patterns were added. A branch passing completely through the picture was chalked in. The heads of the birds were painted using Cadmium Yellow Pale on a ¼ Taklon, and the bills were given a layer of pale blue-grey made up of Ultramarine, Transparent Black and Titanium White.

Following spread: (right) More detail was applied to the main branch below and above the right-hand bird and on the vertical branch behind. The female bird was placed in position on a chalked-in branch. Actually, the female was placed in position and then the branch chalked in to suit her. The female being in the exact position is more important than the branch. The connection between her and the lower male is critical. The interaction between the birds ties the picture together.

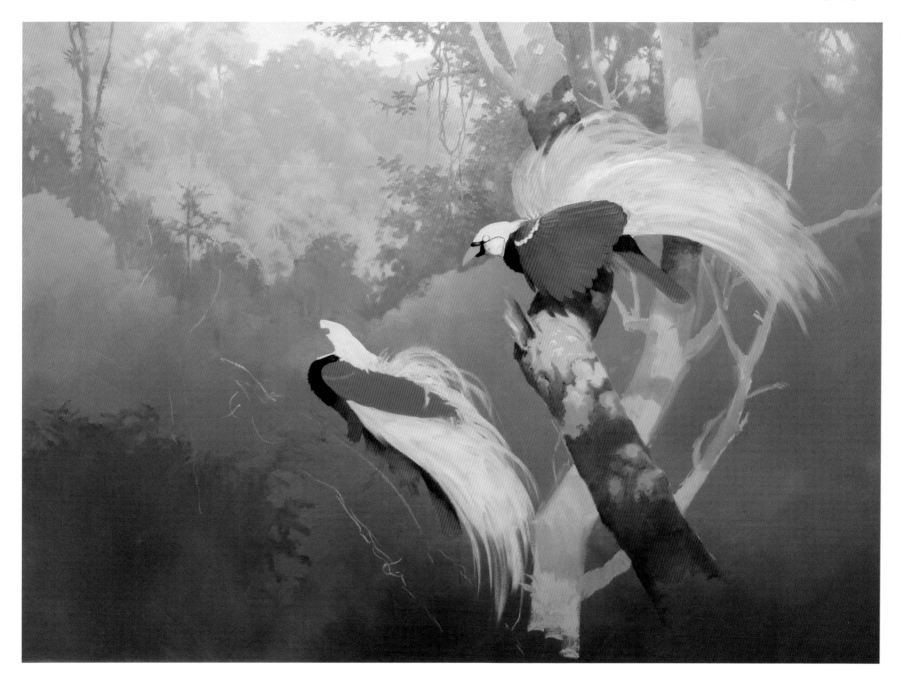

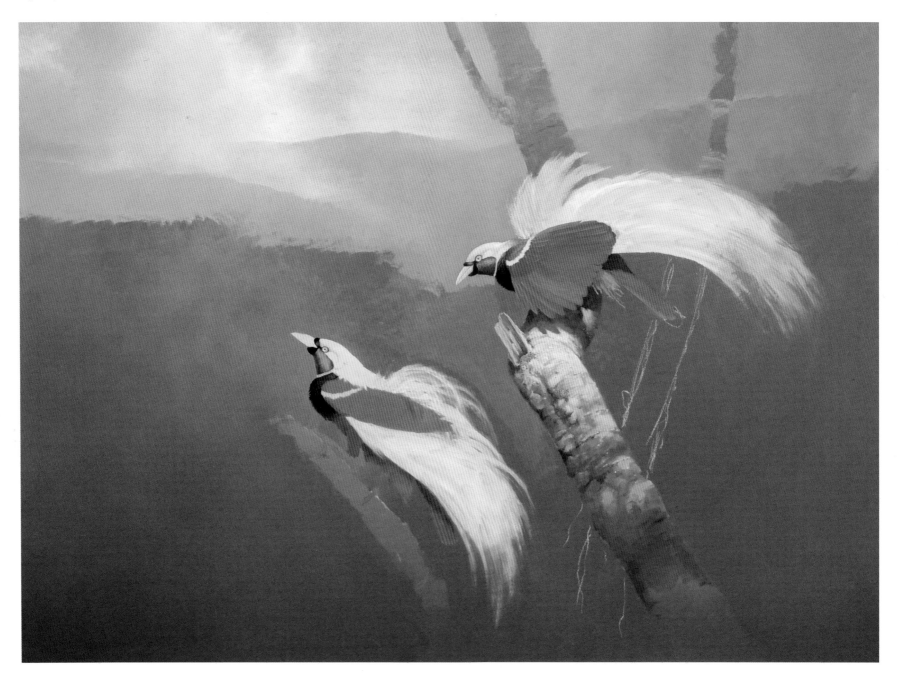

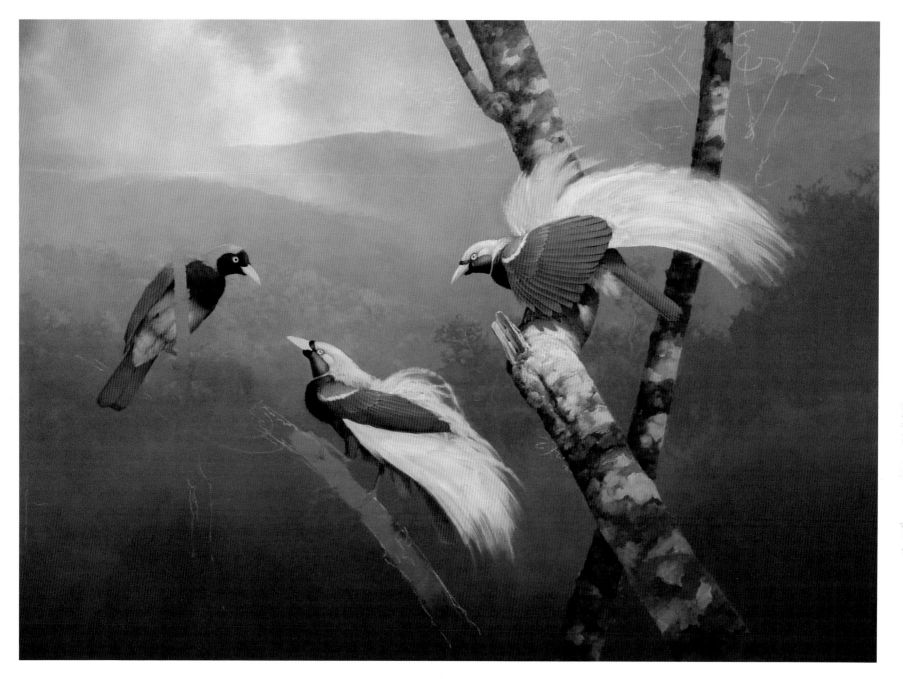

Right: As can be seen in the enlarged detail, light has been added to the tops of trees on the hill slope coming into the picture from the right side.

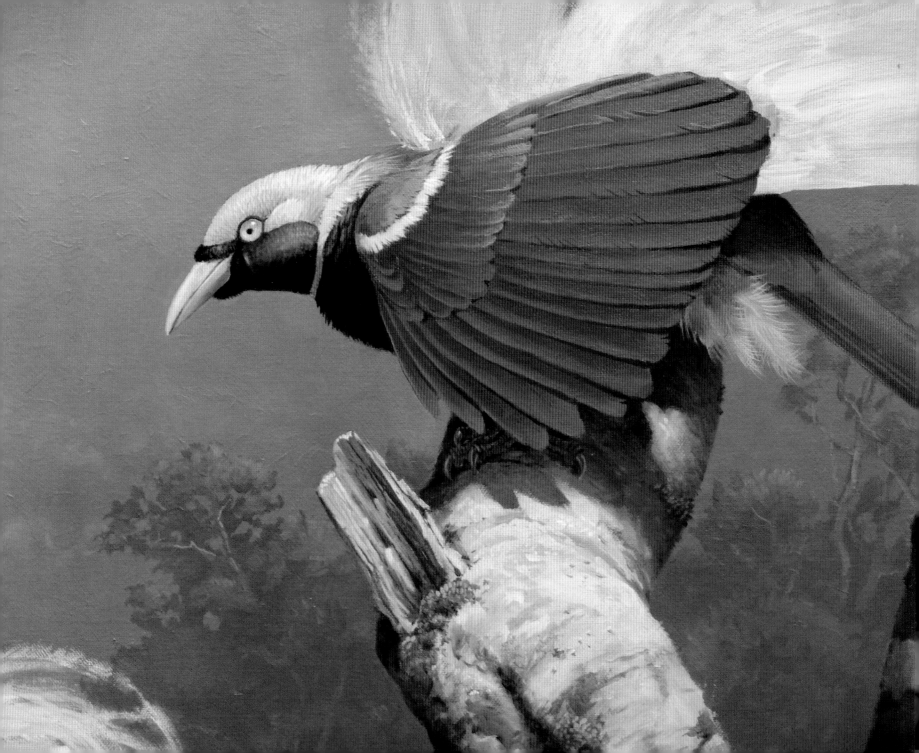

Right: Work on the branch for the lower bird, including his shadow across the branch, began to lift it from the background. Dark tones against light, and light tones against dark, are what create three-dimensional effects.

Some red of the plumes was applied in order to gauge how these colours were going to work with the background. For the red plumes, Light Red was used with a very small amount of Cadmium Red and Titanium White applied with a No. 2 Taklon Script or Rigger.

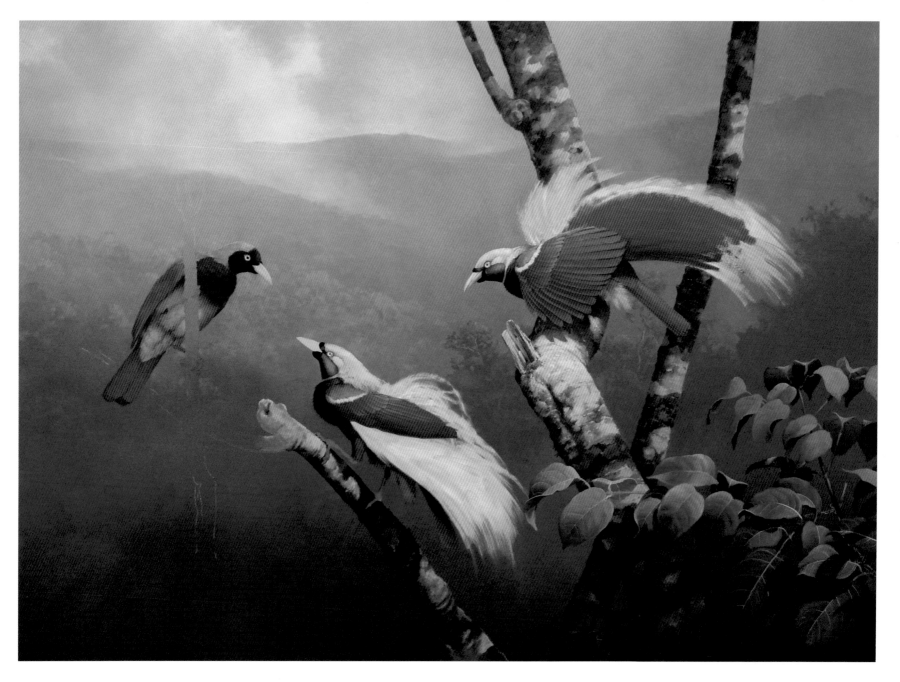

Right: I was not happy with the leaves in the bottom right-hand corner because they looked too flat, so I painted them out with the background colour. The vertical perch that had been chalked in for the female was working against the composition, so her legs were repositioned to take a branch travelling at an angle out of the picture, which was much more compatible with the main branch. The plumes of the males were worked in and fine plume detail added. For this, the paint was thinned to a workable consistency with Liquin and white spirit.

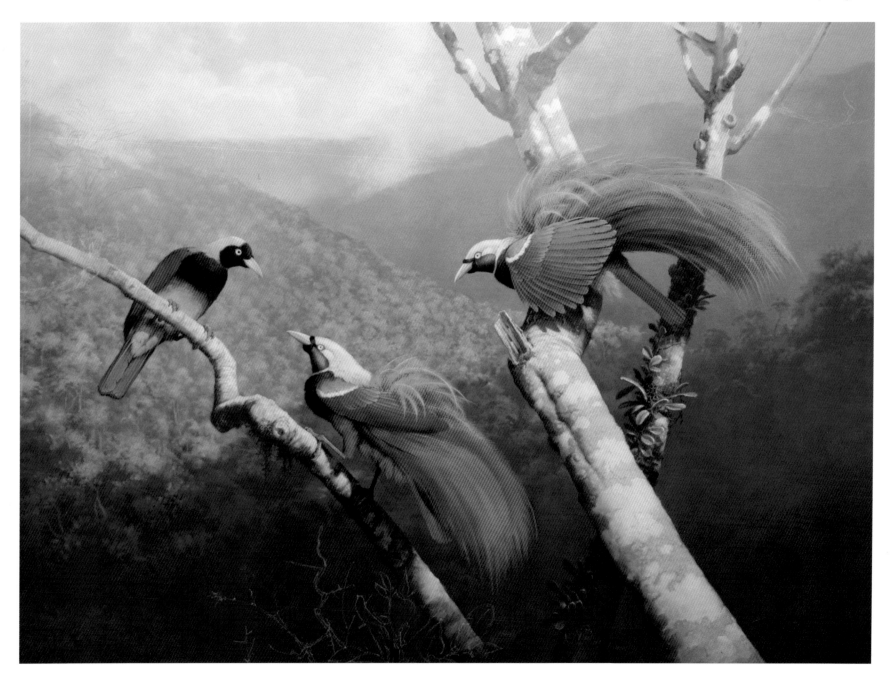

Right: Leaves were added to the branch on the left of the female and to the right-side bottom corner. The pink new tips on these leaves carry a touch of the plume colour into the rest of the picture. The shadows of the leaves pass over the main branch and also onto the left-side branch. These shadows help to lift the leaves from the branch and give it a three-dimensional effect.

Right: As the painting neared completion, the *Pyrrosia* fern that is climbing up the rear vertical branch was continued above the plumes. This helped the branch to appear to pass behind the plumes. The forest background in the gully to the lower left was refined and the closer trees were given more clarity. A tiny touch of light on some leaves below the central bird was added, which helped the perspective.

Finally, I did a careful wander all over the painting to find anything that may not have been properly finished and checked the picture by looking at it in a mirror. This gives you a totally new look at it, and sometimes errors you have become accustomed to while spending hours painting, become evident. When an oil painting is finished I stand it aside for at least 2 months – or much longer if there is any impasto work on it – before applying the finishing varnish. It is important that the paint is properly dry before varnish is applied and this can take up to 6 months if the paint is thick. A solvent finishing varnish, by Matisse, Chroma or Art Spectrum brands are suitable. I prefer to thin a gloss varnish with about 20% white spirit to achieve a less glossy finish. The more white spirit, the less gloss. This varnish must be laid on quickly and evenly with a broad varnish brush. It should be done in one coat. Applying a second coat is extremely risky because it can dissolve and lift the first coat and make a tacky mess.

Conclusion

If, through these pages, I have inspired someone to try their hand at drawing or painting birds – and they experience the pleasure that comes from it – then this book will have served its purpose. It could be that you may never become an artist, but that, in my mind, is less important than the happy, at times exhilarating, experiences and knowledge that come from learning about, and being involved with, birds.

Remind yourself not to be discouraged by your first efforts. If you are not entirely happy with your first steps, put the painting aside and have another go. Each time you attempt a painting, you learn something new and you will be able to see improvements by looking back at your first efforts. I have been painting birds for more than 40 years now, but it is rare that I am completely satisfied with my work: there is always more to learn.

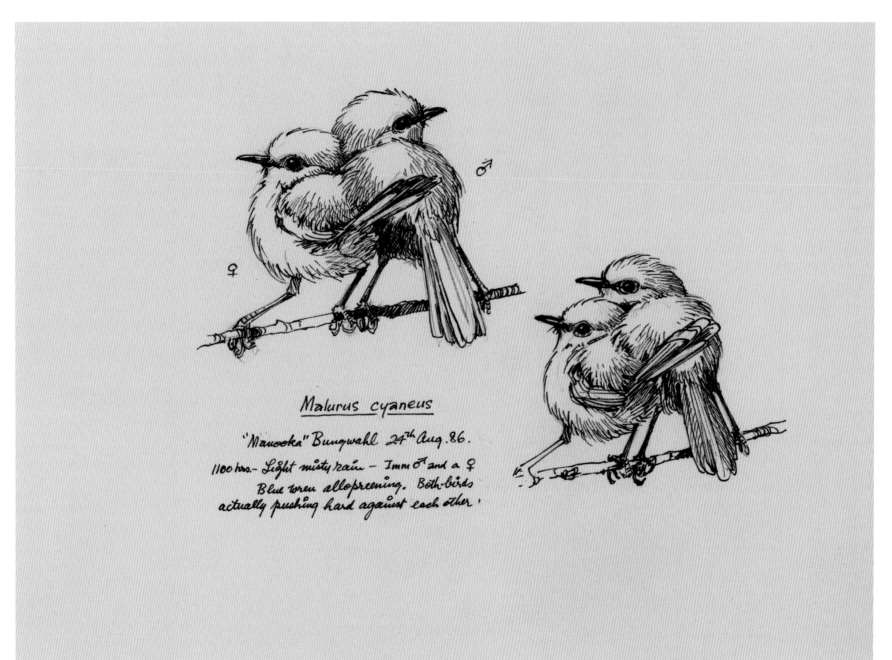

Malurus cyaneus

"Mavooka" Bungwahl 24ᵗʰ Aug. 86.

1100 hrs.– Light misty rain – Imm ♂ and a ♀
Blue wren allopreening. Both-birds
actually pushing hard against each other.

Glossary

cockle – puckers and blisters caused by excessive water on paper.

conté chalk – a traditional material made of compressed pigment and clay. A favourite medium of Toulouse-Lautrec.

culmen – an imaginary line along the centre top of the upper mandible, from the base of the skull to the tip.

diagnostic – assisting identification or diagnosis.

gape – the mouth opening, especially the angle where the upper and lower mandibles meet; most evident when the bill is open.

gesso – a primer for painting supports traditionally made from whiting and glue, but ready made gesso today is usually an acrylic-based primer.

glaze – paint thinned with a medium and laid over an already dried layer of paint. Many layers of glaze can be used to achieve the desired colour.

gsm – abbreviation of grams per square metre; refers to the relative weights of watercolour papers.

gummed tape – a gummed paper tape (usually brown) for fixing watercolour paper to a board when stretching.

hake brush (pronounced harkay) – traditional Japanese brush made from goat hair bound into a flat wooden handle, ideal for washes.

impasto – a textured painting where paint has been applied thickly and the brush or knife work has created distinct relief.

jizz – derived from giss: a World War II fighter pilots' term for the general impression, size, shape and 'feel' of the flight characteristics that distinguished enemy aircraft. Jizz has been borrowed by field ornithologists for use with birds (source: *End of the Earth* by Peter Matthiessen 2003).

mahlstick – a slender wooden rod with a padded knob on one end. It is used to work over wet areas (oils usually) by supporting the painting hand, especially when doing fine detail.

mandible – generally used to describe the upper and lower parts of the bill, but technically 'mandible' refers to the lower jaw, and 'maxilla' to the upper.

media – the plural of medium when it refers to the material used by an artist, such as oils, watercolours, pen and ink, or the actual method used by the artist; i.e. painting, sculpture, drawing, etc.

medium – (1) The liquid constituent of paint in which the pigment is suspended, such as oil or water. The plural of this usage is *mediums*.
(2) The method, such as painting, sculpting or drawing. The plural of this usage is *media*.
(3) The material used, such as oil paint, watercolours or clay. The plural of this usage is *media*.

monochrome – in tones of one colour only.

opaque – colours that absorb the rays of light; not transparent.

rachis – the main shaft of a feather.

sepia – a dark brown colour, originally from the inky secretion of cuttlefish but today is a mixture of Burnt Sienna and Lamp Black.

still life – a drawing or painting of objects arranged usually on a flat surface and lit from one direction. Subjects can be fruit, flowers, books, bottles, fabric or anything not living at the time.

tarsus – is generally thought of as the leg. It is actually the tarsometatarsus formed by the fusion of the tarsal and metatarsal elements (see p. 28).

torchons (tortillons) – are pulped grey paper compressed to make stumps, which are shaped like pencils and sharpened at the ends.

translucent – semi-transparent.

tone – the darkness or lightness of a colour.

tooth – roughness on the surface of canvas or any other support. Tooth gives paint a grip on the surface.

Recommended reading

Bateman R (2002) *Robert Bateman Birds*. Pantheon Books, New York, USA.

Brown L and Amadon D (1968) *Eagles, Hawks & Falcons of the World*. Country Life Books, Middlesex, UK.

Busby J (1982) *The Living Birds of Eric Ennion*. Victor Gollancz Ltd, London, UK.

Collins Artist's Manual – The Complete Guide to Painting and Drawing Materials and Techniques (1995), Harper Collins, London, UK.

Cusa N (1984) *Tunnicliffe's Birds – Measured Drawings by C.F. Tunnicliffe RA*. Victor Gollancz Ltd, London, UK.

Fisher J (1979) *Thorburn's Birds*. Ebury Press, London, UK.

Harris-Ching R (1994) *Voice from the Wilderness*. Swan Hill Press, Shrewsbury, UK.

Hebblewhite I (1986) *Artists' Materials*. Phaidon Press, Oxford, UK.

Hill M (1987) *Bruno Liljefors the Peerless Eye*. The Allen Publishing Company Ltd, Kingston upon Hull, UK.

Jonsson L (2002) *Birds and Light – The Art of Lars Jonsson*. Christopher Helm, London, UK.

Kuhn B (1973) *The Animal Art of Bob Kuhn – A Lifetime of Drawing and Painting*. North Light Publishers, Westport, Connecticut, USA.

Leffel D (2003) *An Artist Teaches – Reflections on the Art of Painting*. Bright Light Publishing, El Prado, New Mexico, USA.

Mayer R (1991) *The Artist's Handbook of Materials and Techniques*. Penguin, New York, USA.

McCracken Peck R (1982) *A Celebration of Birds – The Life and Art of Louis Agassiz Fuertes*. Walker Publishing Company, Inc., New York, USA.

Schmid R (1999) *Alla Prima – Everything I Know About Painting*. Stove Prairie Press, Colorado, USA.

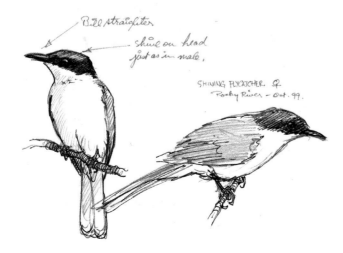

Bill straighter

shine on head just as in male.

SHINING FLYCATCHER ♀
Rocky River – Oct. 99.

ARTIST'S LICENCE

This licence allows the holder to change the shape, tone or colour of any subject on which he or she is working. It enables the holder to claim categorically that the work is exactly as the subject appeared on the day it was painted.

Only if fiercely interrogated about the resemblance of the work to the subject, and if your argument seems to be failing, may this licence be presented.

EXPIRY DATE

{Same as holder}

SIGNATURE

...............................